KT-152-937

WITHDRAWN FROM
ST HELENS COLLEGE LIBRARY

BODY AND SOUL

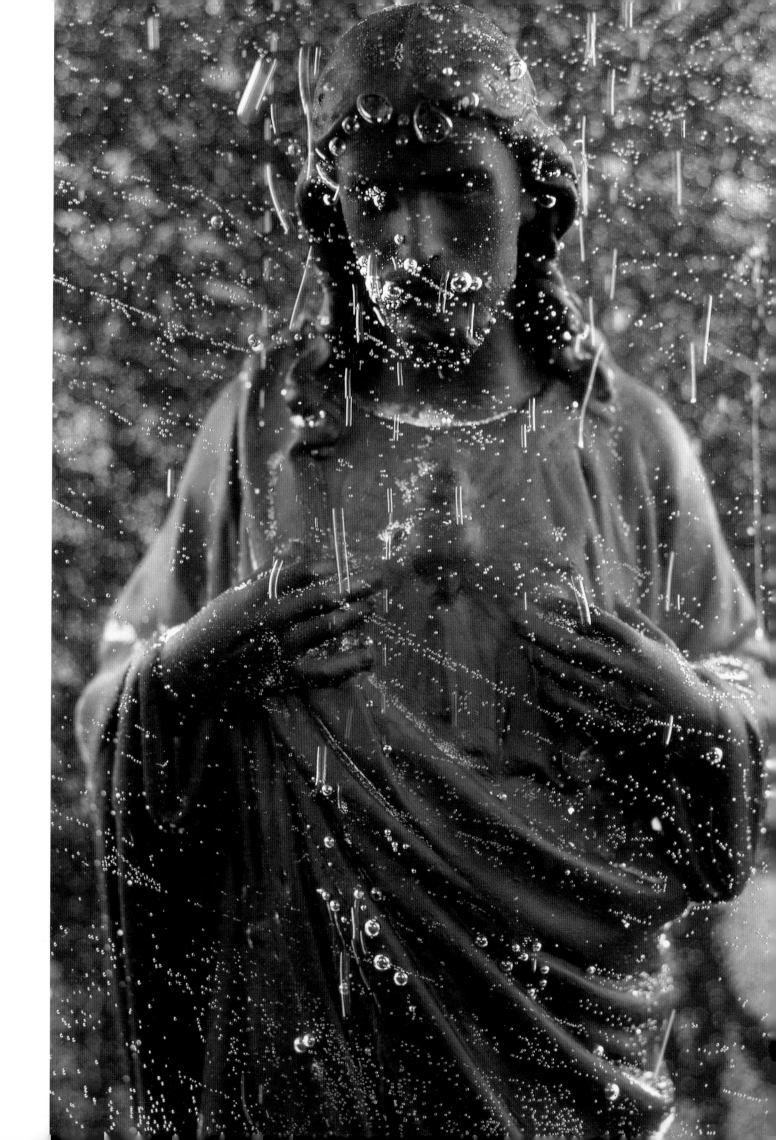

ANDRES SERRANO

BODY AND SOUL

ESSAYS BY BELL HOOKS
BRUCE FERGUSON
AMELIA ARENAS

EDITED BY BRIAN WALLIS

TAKARAJIMA BOOKS

ST. HELENS
COLLEGE

779

83478

JUN 1996

LIBRARY

DEDICATION
FOR MY WIFE JULIE AULT,
AND MIRANDA

ST. ...EEN COLLEGE

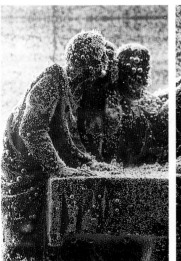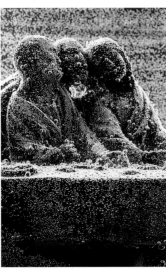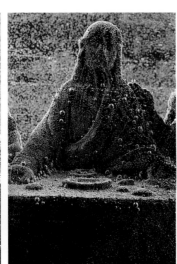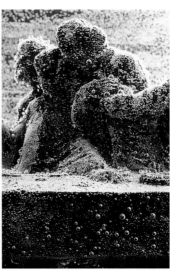

Black Supper, Parts I, II, III, IV, V, 1990

Frontispiece Black Jesus, 1990

THE RADIANCE OF RED: BLOOD WORK BY BELL HOOKS

Dead bodies do not bleed. As children, we marked the intensity of our bonds with outsiders by sharing blood, by cutting our flesh and pressing it against the cut flesh of another. Our blood mingled, we were now one, kin, no longer separated. In the novel *Maru* by South African writer Bessie Head, to share blood is to know another person in a space beyond words: "They did not greet one another. Their bloodstreams were one."

Females in patriarchal society, far more than males, must engage the culture's conflicting and contradictory relationship to blood. Men envy women's capacity to bleed. As feminist poet Judy Grahn chronicles in her book *Blood, Bread, and Roses: How Menstruation Created the World*, this male response grows out of fear: "It has been said that women's blood was held in awe and terror because men saw that 'she bled and did not die.'" Men usurped the power of blood and claimed it as masculine. Woman's blood became a sign of death and danger. She must be punished for bleeding, set apart, the sight of her blood made taboo.

Everyone raised in the Christian church learns to see the blood of Christ as redemptive. On communion days, we drink the symbolic blood to be one with God, to acknowledge the sacrifice of blood that makes growth and new life possible. I vividly recall my first communion, the solemn collective calm that descended as we all raised our glasses to drink together, the preacher's voice which broke the silence to command us in the words of Christ, our Father, "Take drink. This is my blood which was shed for the remission of your sins." We learned then that the blood of the Father is precious, sacred, a sign of compassion and forgiveness. In that same church, we learned that female blood is unclean. No female could walk across the altar for fear that her impure blood would contaminate the purest place of the holy.

Our culture trains the young menstruating girl to hide her blood, to make a secret of the fact that she has crossed the gender threshold that biologically separates her from male peers. Her blood, like that of Christ, is a sign of transition, an indication that an old self has died and a new self has been born. She becomes fully female through the act of bleeding. And it is this blood, not the absence of a penis, that most dramatically marks her difference from the male. Yet, the blood that transforms her being is not sacred; it will not be cherished and blessed like the blood of the Father. It is, instead, the sign of her inferior status, her subordination. As Grahn testifies, "Taboos all over the world indicate that in childbirth rites the point of awe and fear was women's blood, not the birth of the baby." Girls learn to hide all signs of bleeding ("the curse," as it is euphemistically called in patriarchal culture)—this bleeding, once the source of

power, has become a sign of shame.

No wonder, then, that reclaiming the power of blood has become a central metaphor in the contemporary feminist movement's challenge to sexism and sexist oppression. Patriarchy can be undone only as the blood of the woman/mother regains status, is once again held in high esteem. To create a shift in cultural thinking about blood, taboos must be broken. Blood must be taken out of the shadows and made visible.

When he began to use blood imagery in his work, photographer Andres Serrano shattered the cultural taboo that prohibits any public celebration of blood that is not an affirmation of patriarchy. By coincidence, he began this work at precisely the moment when the mass media had begun to warn us that our vital substances could be lethal. Serrano's fascination with bodily fluids also coincided with a more general revulsion at the sight of blood. Hence, the work was destined to be seen as provocative. But the truly radical aspect of Serrano's blood photographs transcends these specific elements of cultural tension; it resides in their fundamental disruption of conventional patriarchal understandings of the significance of blood in our life. In these works, blood is a subversive sign.

Critic Hal Foster's essay "Subversive Signs" begins with the declaration that "the most provocative American art of the present is situated at such a crossing—of institutions of art and political economy, of representations of sexual identity and social life." He contends, "The primary concern is not with the traditional or modernist properties of art—with refinement of style or innovation of form, aesthetic sublimity, or ontological reflection on art as such." In short, this work does not bracket art or formal or perceptual experiment but rather seeks out its affiliations with other practices (in the culture industry and elsewhere); it also tends to conceive of its subject differently. Serrano's blood photographs disrupt the neat, binary opposition that Foster constructs between art informed by "situational aesthetics" and that which uses more formalist or traditional approaches. It is precisely Serrano's strategic merging of traditional aesthetic concerns with the social and political that gives his work its particular edge.

One of the first photographs in which Serrano used blood, *Heaven and Hell* (1984), depicts a cardinal turning away from a nude white woman whose hands are bound and whose head is flung back. Blood streams down her body. This photograph indicts the church as a primary site for the reproduction of patriarchy. Pornographic sadism, captured in this image by the look of satisfied desire on the cardinal's face, enables the patriarchal male to solve the dilemma of his own ambivalence via rituals of brutality. In Susan Griffin's *Pornography and*

Silence, she reminds us that man must destroy the emotional part of himself to ease his terror in the face of what he desires:

> In one who is afraid of feeling, or of the memory of certain emotions, sexuality in itself constitutes a terrible threat. The body forces the mind back toward feeling. And even when the mind wills the body to be silent, the body rebels and plagues the mind with "urgency." And the body, seeking to be open, to be vulnerable, seeking emotional knowledge is threatened, punished, and humiliated by the pornographic mind.

Serrano's symbolic representation of the split between heaven and hell mirrors the sadomasochistic severing of the connection between body and mind.

With this image, Serrano not only graphically calls out the agency of the patriarchal church in the perpetuation of sexualized violence against women and the destruction of the erotic, he also comments on the use of the female nude in Western art. For those in the know, the white male dressed as the cardinal is the artist Leon Golub, but the female nude remains unknown, unnamed. Here, Serrano registers the link between the white supremacist patriarchy of the church (note that the cardinal's robes are similar to those worn by Klan members later photographed by Serrano) and structures of hierarchy and domination in the mainstream art world. Golub, though celebrated in that world, is not representative of the conservative white mainstream. He is the white transgressive male figure caught in the logic of contradiction.

That art world, which continuously marginalizes women and nonwhite men producing art, makes a place for transgressive white males, reincorporating them into the body of the Father they have rebelled against. Woman's deradicalized nude image, on the other hand, is fixed, trapped in the static hold of the patriarchal noose. In *Old Mistresses: Women, Art, and Ideology*, art historians Rozsika Parker and Griselda Pollock emphasize the myriad ways patriarchal ideology is both made and transmitted by the manipulation of images:

> In art the female nude parallels the effects of the feminine stereotype in art historical discourse. Both confirm male dominance. As female nude, woman is body, is nature opposed to male culture, which, in turn, is represented by the very act of transforming nature, that is, the female model or motif, into the ordered forms and colour of a cultural artefact, *a work* of art.

Serrano reproduces this pattern in *Heaven and Hell*, yet he radicalizes it through his depiction of the dripping blood. He exposes the violation—the assault on both the woman's psyche and the psyche of those of us who consume the images, often with pornographic glee. By showing the blood, Serrano pierces the screen of patriarchal denial and demands that we acknowledge what we are really seeing when we look at the female nude in Western art. He forces us to bear witness, either to confront our complicity or to declare our resistance.

A similar demand for the deconstruction of visual allegiance to patriarchal church and state is called for in later images like *Blood Pope III* (1991). In this photograph, the blood that covers the contented Pope's face is not a marker of innocence. It is the exultation of the guilty. The demonic gloat of the sadomasochistic murderer who does not seek to deny the pleasure he derives from domination and death. Serrano uses religious imagery to expose the contradictions in organized or institutionalized religion, particularly the Catholic church. His work critically interrogates the structure of patriarchal Christianity even as it celebrates the seductive mystical dimensions of spirituality. The mystery and the majesty that shroud religious experience are extolled in the photographs of *St. Michael's Blood* (1990), *Crucifixion* (1987), *Precious Blood* (1989), and *Blood Cross* (1985). Artistically, Serrano assumes the mantle of the religious mystic who has been initiated into certain secrets of the church. The ritual initiation he performs for viewers involves both the deconstruction of traditional patriarchal Christianity and the return to a quest for an ontological spirituality.

While challenging the traditional church through a process of graphic desecration and dismantling, Serrano's work also explores and celebrates the individual's quest for spiritual ecstasy. In his introduction to *Thomas Merton on Mysticism*, Raymond Bailey emphasizes that mysticism has always been a threat to the organized church:

> The intensely personal nature of mysticism is inclined to arouse hostility within religious institutions, structures that see in it a threat to discipline and authority. The mystic strives for a direct experience of the absolute without intermediary, institutional or otherwise. Within Catholicism the rise of monasticism with its contemplative orientation occurred during the period of organization and hierarchical power in the Church...The pursuit of direct religious experience as manifested in Church history in the monastic, pietist, and charismatic movements has provided at various times an oasis for the spiritually thirsty who could draw only dust from the structures of organized religion.

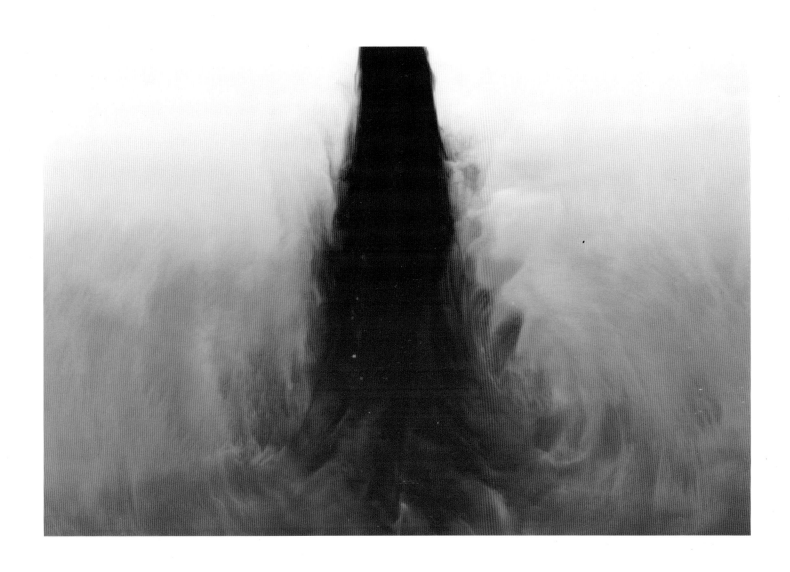

Bloodstream, 1987

In his work, Serrano juxtaposes the oppressive church hierarchy with the world of engaged spirituality, typified by the image of *St. Michael's Blood*. Like the Christian mystic, Serrano artistically re-creates an iconography of sacrament where it is the individual expression of spirituality that is deemed most sacred. That sacredness is present in the ordinary dimensions of human life, in our bodily functions, the urine and blood that mark us. It is only through recognition of the commonness of human experience—in contrast to the elitism and separatism imposed by systems of domination that reinforce the powers of church and state—that individuals can live in harmony, without engendering violence against themselves and others. Contrary to the teachings of the organized church, the individual must be able to accept himself or herself in order to live in peace with others.

This awareness, Merton claims, leads to the understanding that the individual is a "sacrament of God": "Christian personalism is, then, the sacramental sharing of the inner secret of personality in the mystery of love. This sharing demands full respect for the mystery of the person, whether it be our own person, or the person of our neighbor, or the infinite secret of God." Serrano transposes this notion of sacrament to a world of art practices where the individual artist must realize his or her expressive vision via a process of self-realization.

Just as Merton and other religious mystics turn Western metaphysical dualism on its head by insisting that salvation lies in human self-awareness, Serrano insists that artistic self-actualization can be found only in devotion to an aesthetics of transgression wherein all allegiances to fixed static understandings of creativity must be let go. Art practices, canons of art history, and all "Great Traditions" must be interrogated. Essentialist understandings of identity—gender, race, nationality—must be questioned. And hedonistic reveling in the transcendent powers of the imagination must be celebrated.

Critics ignore the ritualistic playfulness in Andres Serrano's work, yet that spirit of reverie is central to an aesthetic vision wherein one dares to bring together the sacred and profane, to defamiliarize by provocation. In the introduction to *Arresting Images: Impolitic Art and Uncivil Actions*, Steven Dubin describes his own visceral response to the Serrano photograph *Milk, Blood* (1986):

As the grandson of a kosher butcher, my immediate reaction was "You don't do this; you don't mix milk and meat. It just isn't done!" Once again this reaction startled me, for although I do not observe kosher laws, this image struck me as a violation of a very basic sort. Categories which I long ago rejected intellectually, I suddenly

desired to uphold emotionally; they seemed natural and inviolable. But not only had they been juxtaposed, they seemed to bleed into one another down the middle of the photo. Unthinkable, and yet here was the record of this transgression.

In this photograph, Serrano flaunts symbolic transgression as a form of ritualistic disruptive play. His point is to remind us that the imagination is a powerful force, one that can lead to a revolution in vision, thought, and action. The blood photographs are as much a commentary on the place of art and aesthetics in ordinary life as they are interrogations of Western metaphysical dualism. Although his work has been seen as pretentious and arrogant, an in-your-face display of very obvious improprieties, Serrano very consciously chooses to work with the most familiar iconic images. His point is twofold: to deconstruct the notion that great art must emerge from "noble" subject matter, and to challenge conventional understandings of beauty.

Indeed, one of the most disturbing aspects of Serrano's blood photographs to many viewers is the startling beauty of these images. The blood that we associate more and more with a world of impurity, violation, and death, is spectacularly transformed in these photographs. Whether it is the beautiful displays of menstrual blood in the *Red River* series (1989), the distilled images of *Piss and Blood* (1987), or just the bold luxury of *Blood* (1987), this work challenges the senses, demands that we see in bodily fluids the possibility of a resurrection and renewal that empowers, that redeems.

To bring us back to blood as a life force, to counter the cultural images of dangerous blood (associated with the AIDS crisis), Serrano's work urges us to luxuriate in the ecstasy of red. This work is not solely an exploration of the cultural politics of blood, it is also an artistic invitation to revel in the power of color. Celebrating the diverse meaning of the color red in *When the Moon Waxes Red*, writer Trinh T. Minh-ha insists that it is the sign of contingency: "At once an unlimited and profoundly subjective color, red can physio- or psycho-logically close in as well as open up. It points to both a person's boundless, inner voyage, and the indeterminate out burning of the worlds of war. Through centuries, it remains the badge of revolution."

Serrano chooses to photograph blood only when it is bright, when it saturates the image with a sense of passion and warmth. Red makes the intensity in these images. Trinh contends that "the symbol of red lies not simply in the image, but in the radical plurality of meaning." Serrano's use of the color red is the indicator that we must not just assume that the works address only what the images make superficially obvious. Each meaning of red is textured, layered, a palimpsest on which he inscribes

narratives of religion, culture, identity, art, and aesthetics.

Red is the color used to challenge our fixed visions of art and culture. Trinh says that red invites us to understand that "society cannot be experienced as objective and fully constituted in its order; rather only as incessantly recomposed diverging forces wherein the war of interpretation reigns." These diverging forces, sometimes conflicting, are ever-present in Serrano's work. He mixes them together in an elaborate gesture of border-crossing and transgression; he announces that order is to be found by embracing the limitations of our capacity to know and control the universe. It is this vision that is evoked by the mandala image in the photograph *Circle of Blood* (1987).

"An archetype released by the unconscious, the circle is a universal symbol of essence which is, which becomes, and which returns to itself; thus indicating how every form is in itself whole, self-consistent, a paradigm of a larger whole," Ajit Mookerjee explains in *Yoga Art*. "The mandala is wholeness. The never-ending circle transcends all opposition, imaging the ideal Self to itself." In *Circle of Blood*, the abstract image of wholeness converges with recognition that the circulating blood is central to continuity of being—that spirit of wholeness which the circle evokes. Even the field of yellow that encircles the red—suggesting sun and light—unites the very concepts of body and nature that Western metaphysical dualism tries to keep separate. Here, nature's life-giving restorative symbol, epitomized by the sun, is reflected in the blood which circulates to renew life.

This same gesture of reunion is present in the photograph *Blood and Soil* (1987), where again an aspect of the natural world (the earth) converges with bodily fluids to remind us of an organic framework of wholeness. These juxtapositions both interrogate and call for the restructuring of our priorities. While not as overtly transgressive as many of the Serrano photographs that use blood, these images are political and powerfully subversive. They challenge us to decenter those epistemologies in the West that deny a continuum of relationships between all living organisms, inviting us to replace those modes of thought with a vision of synthesis that extols a whole that is never static but always dynamic, evolutionary, creative. Though often overlooked, this is the counterhegemonic aesthetic vision that is the force undergirding Andres Serrano's work.

ANDRES SERRANO: INVISIBLE POWER BY BRUCE FERGUSON

The circumstances surrounding the initial reception of Andres Serrano's art require a consideration of that work within a broad cultural context. To even begin to address this issue means opening up and traversing the nasty thicket of competing political factions in the United States during the 1980s, an ongoing conflictual situation now generally known as the "culture wars." But, at the same time, any consideration of Serrano's work that follows an exclusively sociological path runs the risk of minimizing or forgetting entirely that his photographs simultaneously offer a unique opportunity to consider and experience some of the principal aesthetic issues of the period. Among these are: the complex nature of realistic images, the relation between words and visual images, and the unique sociopsychological impact of both.

It is no coincidence that Serrano's rich visual work in photography opens onto a curious political landscape at one moment in a troubled national history, and also provides a glimpse of strange and enduring aesthetic forces. There is a plausible symbiosis to be found in his work (in the still lifes, in particular) between the political and the aesthetic; these elements inform and problematize one another. Serrano's photographs provide a sort of meeting place for the rational and irrational, a border condition where they seem to eventually reverse positions. The photographs are increasingly real; the politics seem surreal, or even unreal. But, above all, while Serrano's work is the result of a specific social history, it is also the product of an individual struggling to define issues of personal identity through representation. Any consideration of the work's social context only encourages further questions regarding artistic biography. Mired in reality but reflecting a utopian desire, Serrano's work prompts a spiral of reflections and refractions, a vertiginous whorl of meanings on all sides.

1. In a Conservative Landscape

By all accounts, Sen. Alphonse D'Amato launched the culture wars when he ripped up a copy of Serrano's photograph *Piss Christ* in the chambers of the U.S. Senate on May 18, 1989. The ideological battle that followed was the result of a systematic attempt by conservative Republican politicians, neoconservative intellectuals, and religious fundamentalists in the late 1980s to control expression in American culture. For D'Amato and other proponents of this conservative backlash against liberal "excess," Serrano's work was symptomic of the overabundance of free expression in governmental entitlement programs, such as federal funding for the arts. But behind the fiscal restraint of these antiexpression partisans was an insistently conservative moral attitude that exploited scarcely acknowledged but clearly identifiable social fears, particularly regarding sexuality and the body. The term "culture wars" was a deliberately provocative label: originally posed as a declaration of aggression by right-wingers against seemingly benign cultural forces, it was meant to dramatize the seriousness of the social choices facing Americans.

Unrestrained by the prefix "culture," the word "war" correctly connotes the combativeness and social upheaval that, for well over a decade, have accompanied the carefully controlled conservative assaults on various forms of symbolic representation. Beginning with the election of Pres. Ronald Reagan in 1980, and spurred by the fundamentalist Christian zealots who supported him, the culture wars have constituted an all-out opposition to cultural expressions emanating from the new social alliances formed in the 1980s around issues of gender, race, ethnicity, and sexual orientation. This war has included attacks on television sit-coms, mainstream movies, rock lyrics, university curricula, and art. Although some battles have been won and lost by both sides, the war is far from over.

By no coincidence, the use of art as a form of political activism came into its own during this same period. Serrano, for one, was in direct contact with Group Material (an artist-run curatorial collective), as well as such noted artist-activists as Tim Rollins, Lucy Lippard, Nancy Spero, Tom Lawson, Leon Golub, and Julie Ault. In general, there was a contentious and continual influx of issue-oriented and identity-related art into mainstream institutions during the decade of the 1980s, the Age of Reagan. This was a result of several factors, not the least of which was the growing conservative political climate in the United States. But within various arts institutions, there were other changes that fostered such attitudes. Art-school teaching reflected demographic societal changes and a new, more critical approach to art making. Interventionist work was also deliberately sought out by a new generation of socially conscious curators. And the social role of art and the effect of its political context on the range of possible meanings had become highly politicized critical concerns.[1]

As democracy itself was being systematically dismantled at the level of political and cultural participation, arguments about representation and about the rights of the represented were amassed at diametrical poles of the social and intellectual spheres. The right-wing repression of individual rights (such as abortion) and collective rights (as represented by the Reagan's hostile reaction to the 1981 air-traffic-controllers' strike, for example) during this period also included a low-level but consistent attack on the National Endowment for the Arts and other arts organizations.[2] The debilitating blows took the form of

direct cuts in funding and direct and indirect censorship of words and images. In retrospect, these policies can be seen as a highly regulated and cynical political disguise, an easy bluff by an exhausted governmental culture which was ethically bankrupt and on the verge of economic collapse.

This "politics of diversion," as sociologist Steven Dubin has called it, was designed to manipulate public response to the art "which came under interrogation, and to use it to redirected ends."[3] As Dubin argues, the ploy had its psychological roots in the waning status of the United States in the world political sphere; in the breakup of communities that were economically and socially undermined by Reagan/Bush privatization policies; and in the breakdown of myths of familial stability.[4] Certainly, those circumstances, which also encouraged the rise of the religious right, are more plausible explanations for the culture wars than any claims to superior moral or aesthetic values.

Another deceptive feature of the culture wars is the way they were conducted through the national media in order to present the image of a moral and righteous government, precisely the sort of image that was being threatened daily by news of various scandals, criminal actions, and other forms of social destruction. By rhetorically claiming a moral high ground, the Reagan and Bush administrations were able to contradict or hide their offenses behind an appearance of superior virtue. At the very least, the disinformation claims partially gave credence to the controlled myth that such crimes were merely the unauthorized actions of rogue employees (e.g., Oliver North and the Contras) or misled citizens (e.g., Jeb Bush and the savings-and-loan swindlers). However objectionable such behavior might have been in a nostalgic "civic" past, the examples are clear and unfortunate evidence of the success of the subtle fanaticism of the recent right-wing assault.

At key moments in this highly contentious debate, Serrano's photographic work was a memorable quicksilver catalyst. Arguments around images such as Serrano's *Piss Christ*, a work which became infamous through the attacks on it, can now be seen as part of an elaborate and partly conscious foil to make an irresponsible government seem less irresponsible. Or it can also be seen as the scapegoat of hypocritical neo-Christian groups to counter their own examples of violence, bad faith, and, more importantly, bad press (as in scandals involving televangelists Jim Bakker and Jimmy Swaggart). In a strange and paradoxical way, works of art were used as counteradvertisements for politicians and religious groups lacking strong representations of their own. Serrano himself was aware of this dependency model, saying of Sen. Jesse Helms, "I helped him in some ways and he helped me: he got re-elected and I became who I am."[5]

It is perhaps not so surprising, then, that visual art production, an area with seemingly little direct political power (despite the influence of some artists), was singled out for massive reprobation by social and political conservatives. As with similar attempts to control the uses of the American flag (yes to Roy Rogers wearing it, no to Abbie Hoffman; yes to Jasper Johns's paintings, no to Dread Scott's installation), the social dimensions of symbolism are always paramount at moments of high social and political tension. Historically, as Dubin points out, "whenever a society is overwhelmed by problems and its sense of national identity is shaky or diffuse, a probable response is for states to attempt to exercise control by regulating symbolic expression."[6]

In moments of national weakness, the impulse to "persuade" by authoritarian intervention is strongest. Like desperate bullies up against the wall anywhere, political and religious leaders in such circumstances will disobey or ignore ideas of justice in favor of brute behavior. And in the culture wars of the 1980s, the work of Andres Serrano and Robert Mapplethorpe came to symbolize certain social ills. Encapsulated as representations, these issues could be caricatured and dismissed, without ever confronting the underlying social differences or contradictions which made them frightening to some people. Blaming the messenger for the message is still, seemingly, a highly effective political tool.[7]

2. The Radical Figure

Curiously, the artist who so threatened these conservatives is himself rather conservative. Serrano is no avant-gardist, no interventionist, no social activist. He is a photographer who works almost exclusively in the traditional genres of still life and portraiture, two of the cornerstones of conventional art practice.

An early work, *Cabeza de Vaca* (1984), is a perfect example of a subject which in and of itself is neither provocative nor radical, but which inspires complicated connotations and readings. This large color photograph depicts a simple still life of a severed cow's head. But, beyond the literal level, the image has rich emotional and social associations which are largely invisible. Certainly the most obvious referent is death: a mortal head severed from its torso, a brain split from its body. But the suspicious, even aristocratic, bovine eye, which accuses from the afterlife, also alludes to the possibility of the soul. And, here, sickening blood, the very sign of sacrifice, is not disguised or hidden.

This image lifts a veil of decorum. It is a horrible picture, an everlasting reminder of genocide, slaughter, and slaughterhouses, the very topics the bourgeois world has usually swept from view. German literary critic Walter Benjamin

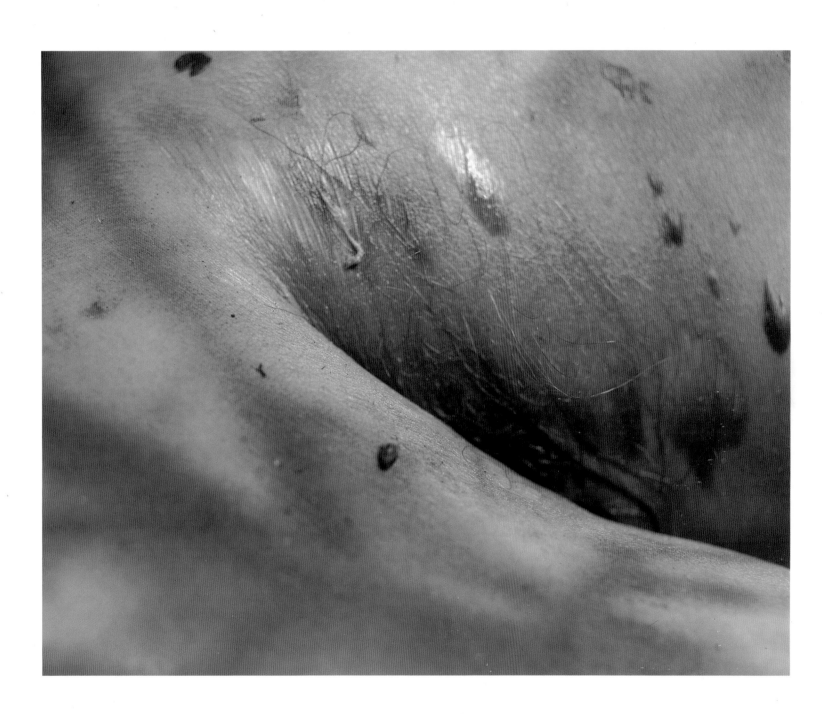

The Morgue (Death By Drowning), 1992

commented on the invisibility of death in modern culture when he noted, "In the course of the nineteenth century, bourgeois society has, by means of hygienic and social, private and public institutions, realized a secondary effect which may have been its subconscious main purpose: to make it possible for people to avoid the sight of the dying."[8] This concerted attempt by various bourgeois institutions to obscure certain "unsavory" elements of the culture is part of the same litany of shame that informs and produces much religious and political dogma—as in the culture wars. Such programs of official invisibility attest to the power of authorities everywhere to "protect" citizens from the unseemly, the repulsive, and the grotesque.

By returning to his own early influences in latinized Catholic aesthetics—though without the superstition and ideology generally attached to it—Serrano began to build a rich visual vocabulary. As with his subsequent work with bodily fluids (milk, blood, urine), the cow's head is presented in a quasi-scientific or abstract fashion. What is more, *Cabeza de Vaca* is a close-up, a detail, the perfect vehicle for an inversion of the seemingly invisibile. In the movies, a close-up never reveals the full scene but communicates through suggestion; it is always the carrier of a certain desire for narrative, which underlies the viewer's need to structure a larger meaning. The close-up never delivers complete meanings, only fragmentary plentitude, supplements. For Serrano, the close-up offers ambivalence.

The cow's head is also an everyday image, a slice of life. But, if it fulfills the fiction of objectivity dominant to discussions of still lifes and portraits and of photography in general, this simple prop also delivers us rather dramatically to the realm of the subjective. The cow's death pierces the emotional boundaries which police the distinctions between representation and reality, distinctions maintained only by careful administration of dualities such as body and soul, rational and irrational, flesh and spirit. So, the cow's head is not, after all, a mere thing, but a symbol of emotional and even mystical incantation. This wordless communication is enhanced by the mimetic empathy of photography, which acts as a trace or stand-in for the values symbolized. Serrano himself noted this sort of confusion with regard to religious imagery: "What the nuns told us in school when I was going to religious instruction was that we worship not the crucifix but Christ…We weren't supposed to worship the symbol or give it the same level of reverence that we give Christ, because it is only a representation.[9]

Despite seeming to depict death in a literal way, Serrano still is compelled to visually investigate its abstract and even spiritual significance. Pursuing "constructed" photographs from 1983 on, Serrano has always, even in less strong works,

tried to work through his own doubts about representation and spirituality, both by repeating photography's own death wish and through images of death.[10] Unlike other artists who work with deconstructive photographic methods (Cindy Sherman, Laurie Simmons, James Welling, Adam Fuss, to name a few), Serrano is more comfortable using a kind of heightened realism which aspires to metaphor and beyond.

Connected directly and deliberately to an art-historical tradition that glorifies the grotesque and the dramatic (a lineage that includes Caravaggio, Mantegna, Goya, and El Greco), Serrano is deeply concerned with the relation between what is seen and what is unknown, between appearance and the anxiety of meanings. For him, photography is the practical site for this ambiguous and complex investigation. Despite its seemingly transparent relation to reality, photography's hold on the world is illusory. It is a delusion of eternity, of holding onto a disappearance forever—of stopping time.

When Serrano repeats, as he often does, that photography for him is really "painting," he is more aware of the photographic process as a rhetorical device than many artists, and certainly more so than most fundamentalists. He is not simply denying an empirical fact but rather admitting to and allowing for photography's potential for deception, or at least fiction. As Walter Kendrick has written, "The power of representation derives from the nature of representing, not from the thing or action represented in any particular case. The practice of treating this power as if it belonged to only a special class of images leads directly, as the history of 'pornography' has shown, into a hopeless muddle."[11] So, Serrano's deliberate use of the scale and lush color of painting is perhaps less radical than his understanding that photographs, even realist ones, are constructions.

Without irony or deconstructive theory, then, Serrano's photographs of bodily fluids evoke subversive social connotations. He relies on the power of the photographic image to reproduce faithfully the natural abstractions, just as a priest might rely on an icon. They are felt by him, first, at a visceral level, and then, secondly, by viewers, who either confuse the representation with reality or who confuse the charged associations with representations. Either way, the very strange fidelity of the photograph to its referent touches an emotional, preliterate, regressive chord. Before thought can intrude, Serrano's work is erotically seductive—which, in part, explains the furor surrounding it.

Another aspect of Serrano's brilliance is to attach a label to the image. In this way, he produces the shock that contradicts or increases the seductions of the lush photograph. It is this union of the word and the image that concretizes the moral charge of his best works, embedding it for good in a contest of

subversion. If *Piss Christ* were *Ginger Ale Christ*, there would be no possible challenge. And, despite the title and Serrano's assurance that it really is piss that the crucifix floats in, there is no way to tell by looking. It is the combination of the instability of language with the instability of the photographic image that sustains the frisson.

If photography can be used to lie, as Serrano reminds us, so too, can language.[12] So, through its intriguing marriage to fickle language, the image begins its most productive work. Titles are more than labels, they are rich, allusive, poetic suggestions. The title *Cabeza de Vaca*, for instance, means more than the literal cow's head or the symbolic death's head. It also refers to the Spanish explorer and New World imperialist who owned that curious name.[13] Similarly, *The Scream* (1984) breathes new life into a dead coyote. And *Meat Weapon* (1984) makes the phallic character of the lamb's leg deadly and aggressive. Even *Milk, Blood* (1986) makes explicit what had once been only formal and aesthetic.

This poetic use of titles is most potent in the morgue pictures. There, the grossly enlarged details are made insufferable by their associations with the various gruesome methods of death: pneumonia due to drowning, AIDS-related death, knifed to death, accidental drowning, or fatal meningitis. But this device, this ruthless use of descriptive language, is also deployed effectively in the naming of the "Nomads" (*Bertha, Johnny, McKinley, Payne*) or even the religious statuettes (*Black Supper*, for example). By their presupposition of objectivity, all these titles act to underscore the criticality at work. The photographs (documentary evidence) and the titles (descriptive names) do not add up; they do not provide comfort or what social philosopher Herbert Marcuse called "affirmative culture"; they do not maintain the traditional relations between society and its institutions.

When metaphors are literalized, when the anonymous are named, when the violence of stigmata is inscribed outside of its romantic depictions, it requires a serious rethinking of the relationship between images and words and their referents. We realize how unstable that relationship is, how that relationship can be fictionalized, manipulated, and put to use. By digging back into realism and its attendant myths of objectivity and empirical status, and by using language in a coyly neutral manner, Serrano produces the "alienation effect" desired by so many artists of the historical avant-garde. Rather than move toward a new form or a new vocabulary, Serrano lets these traditional forms collide and crash and mingle promiscuously. Much like the variegated materials within many of the images themselves, the admixing of language and image, too descriptive

to be true, causes an uneasy destination to be produced, a space in which the contestations are not closed and over, but open and possible. This is a space where the irrational of faith is legitimized in the materiality of death.

1. There are many sources and even now many books which give these histories. For a quick review of the issues, see Lisa Phillips, "Culture under Siege," in *Whitney Biennial 1991* (New York: Whitney Museum of American Art, 1991), pp. 15-21. The best history and analysis of Serrano's work which gives biographical influences, art historical and social references, and astute iconographical analysis is Lucy R. Lippard, "Andres Serrano: The Spirit and the Letter," *Art in America* 78 (April 1990): 238-45.

2. For an informative discussion of the partial failure of such direct policies on the National Endowment for the Arts during that period, see Carole S. Vance, "Reagan's Revenge: Restructuring the NEA," *Art in America* 78 (November 1990): 49-55. Vance makes the strong case that policies, when advocated by government as economic concerns or as a question of elitism, were met with widespread resistance from many quarters. However, and ironically, today the NEA is being disenfranchised from within and without because of what she calls "sex panics." By turning their attention to individuals whose art is concerned directly with sexuality, cultural conservatives are able to tie the arts to questions of the body associated with obscenity and pornography—larger and more fear-producing cultural issues—in a widespread method of repression which overlaps other social anxieties.

3. Steven C. Dubin, *Arresting Images: Impolitic Art and Uncivil Actions* (London and New York: Routledge, 1992).

4. Despite the seemingly indomitable position of the United States, its true international power was waning in the 1980s. As Michael Ignatieff puts it, "The Americans may be the last remaining superpower, but they are not an imperial power: their authority is exercised in the defense of exclusively national interests, not in the maintenance of an imperial system of global order." See his *Blood and Belonging: Journeys into the New Nationalism* (New York: Farrar, Straus & Giroux, 1993), p. 12.

5. Serrano, quoted in Terry Gross, "Irreverent Images," *Applause* (May 1993): 14.

6. Dubin, *Arresting Images*, p. 19.

7. Such censorship has not been confined to the United States in recent years. When a dress made of salted flank steaks by artist Jana Sterbak was exhibited at the National Gallery of Canada in Ottawa in 1991, it caused an uproar. Debates about the dress in the Houses of Parliament centered on public funding of art, the nature of obscenity, the potential health hazard, and the artist's insensitivty to the homeless and hungry. In Turkey in 1992, at the third Istanbul Biennale, local artist Hale Tenger built a wall-sized Turkish flag made of small souvenirs of a priapic Uratian fertility god. She was arrested and charged with blasphemy against the state. And in London in 1993, the police papered over the windows of the Serpentine Gallery so that passersby would not be able to glimpse Robert Gober's *Male and Female Genital Wallpaper*. These events are not isolated but are part of a larger, international attempt to control symbols.

8. Walter Benjamin, "The Storyteller," in *Illuminations* (New York: Schocken, 1969), p. 94.

9. William Niederkorn, "Artist Defends Depiction of Christ," *Boston Globe*, Aug. 20, 1989, p. 89.

10. In his usually casual but acute way, Serrano says, "The camera lies, it also tells the truth: that's the beautiful contradiction." See "Andres Serrano: In Conversation with Simon Watney," in *Talking Art I* (London: Institute of Contemporary Art, 1993), pp. 119-28.

11. Serrano speaks directly about this when he says, "Most artists, if they're interested in life, and I assume they are, are also interested in death. To me, its not extraordinary to want to portray death. A lot of painters have done it throughout history. I think everyone is concerned with mortality." See Gross, "Irreverent Images," pp. 12-15.

12. Walter Kendrick, *The Secret Museum: Pornography in Modern Culture* (New York: Penguin Books, 1988), p. 40.

13. Critic Lucy Lippard offers this punning connection to the Spanish conquistador Alvar Núñez Cabeza de Vaca (born ca. 1490), who explored much of what is now the Gulf Coast of Texas. See Lippard, "Spirit and the Letter," p. 242.

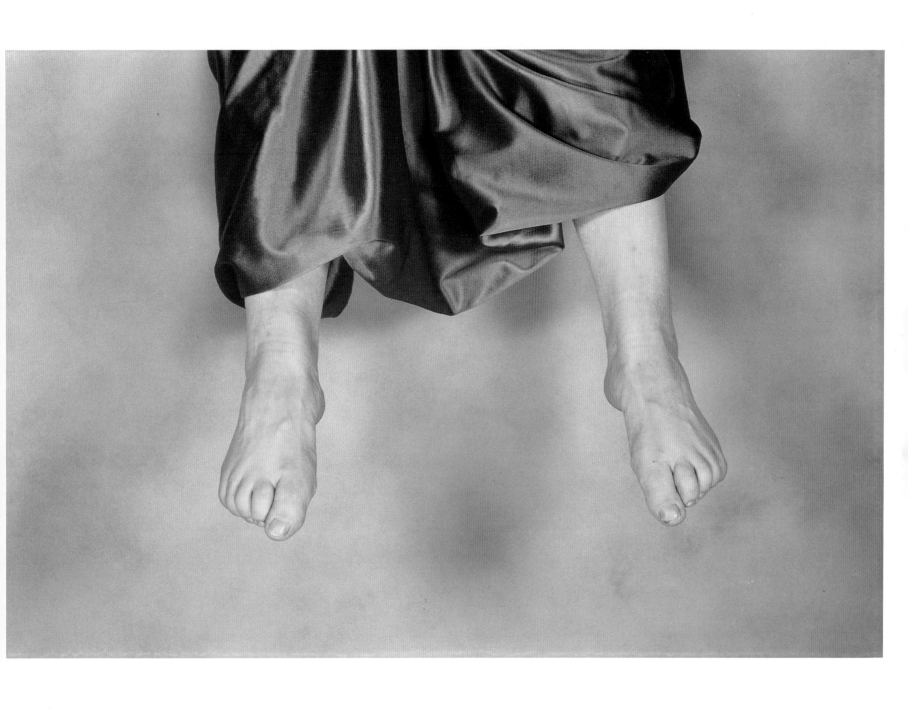

Ascent, 1983

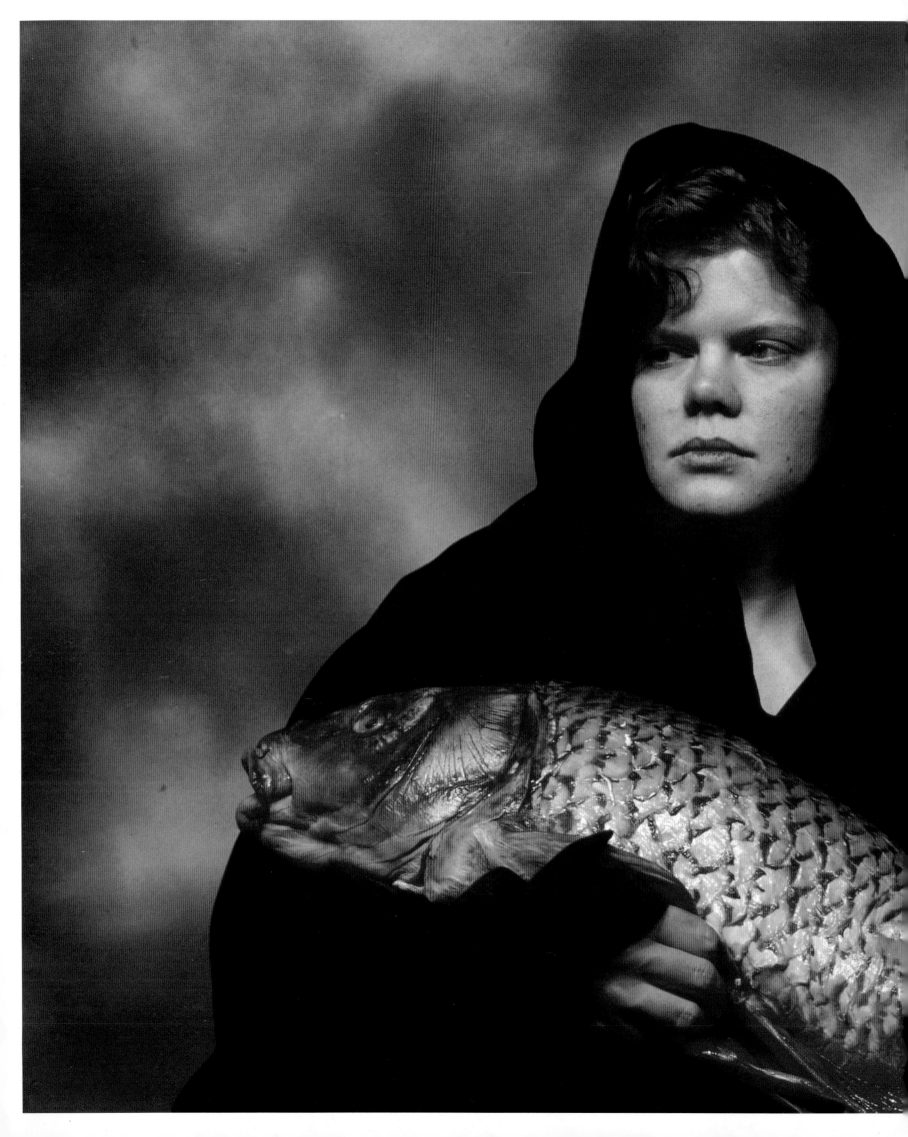

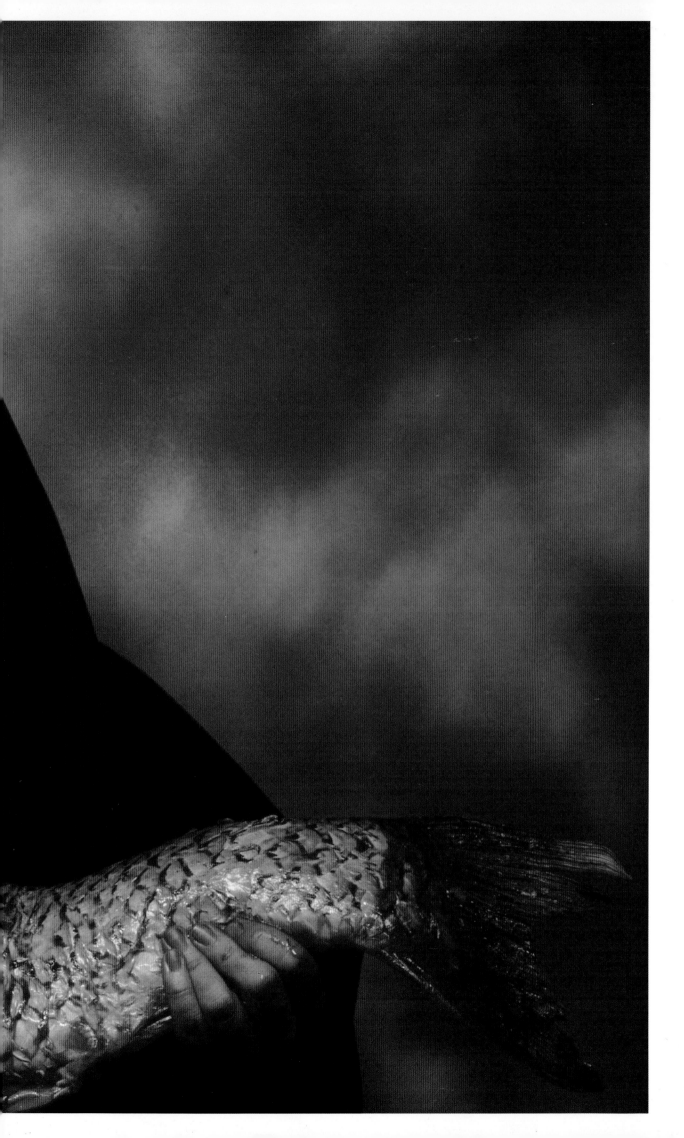

Pietà, 1985

The Scream, 1986

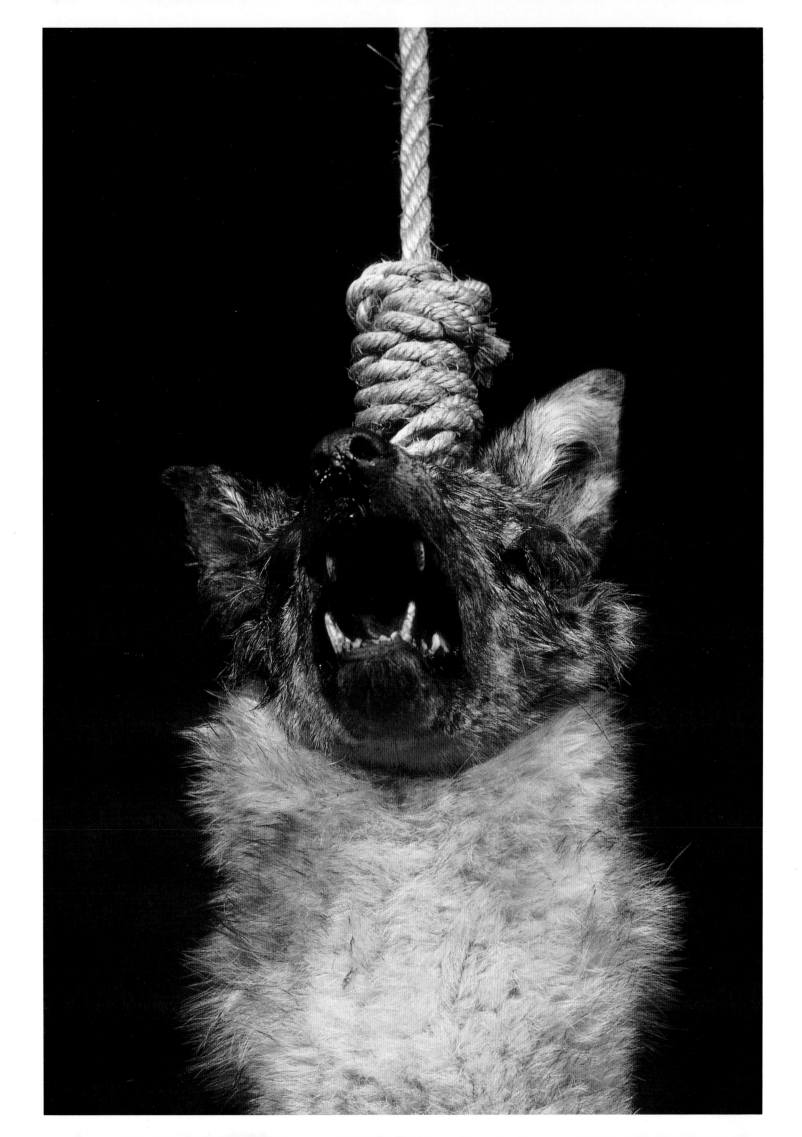

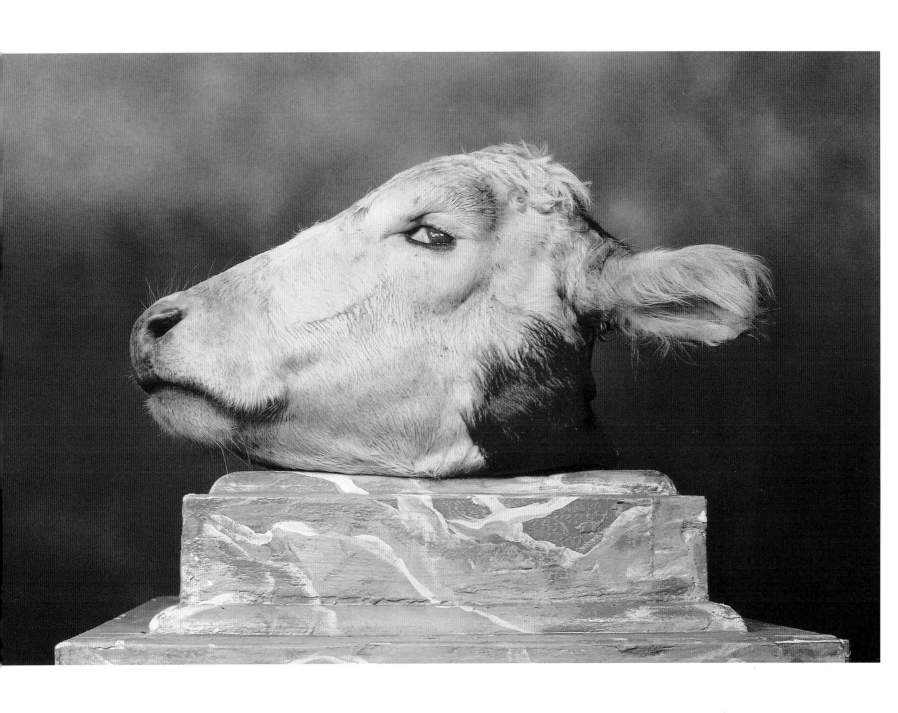

Cabeza de Vaca, 1984

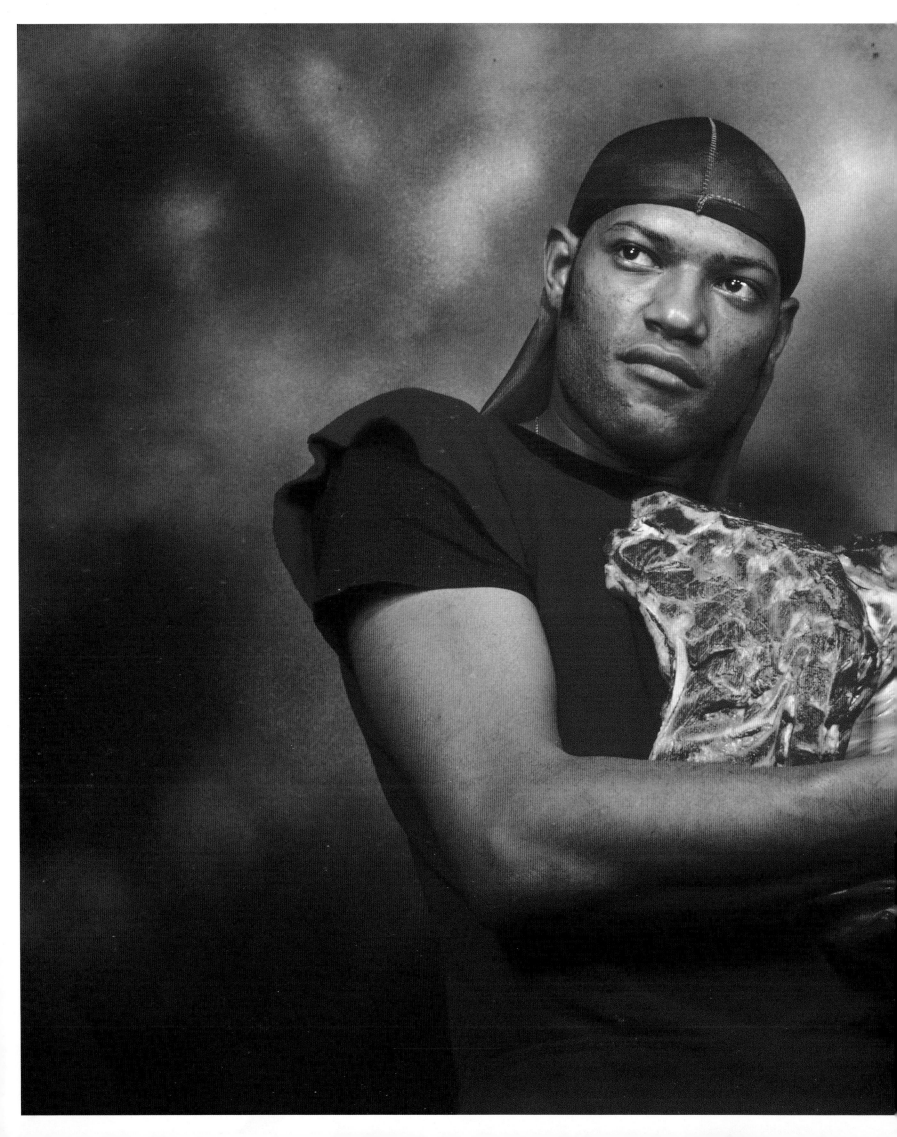

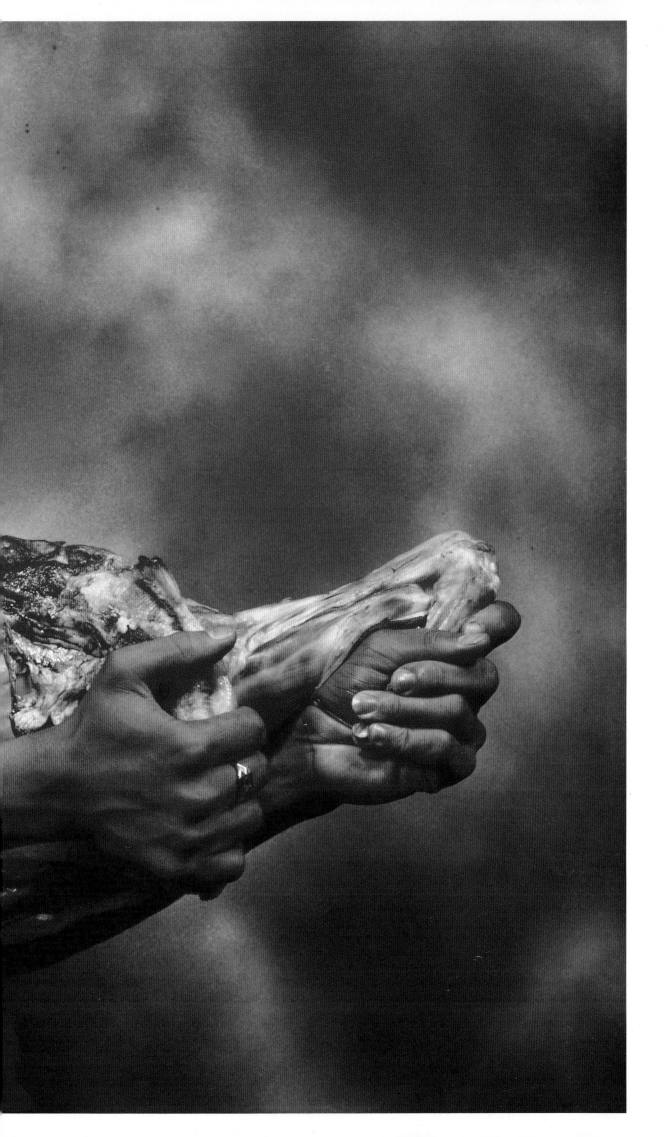

Meat Weapon, 1984

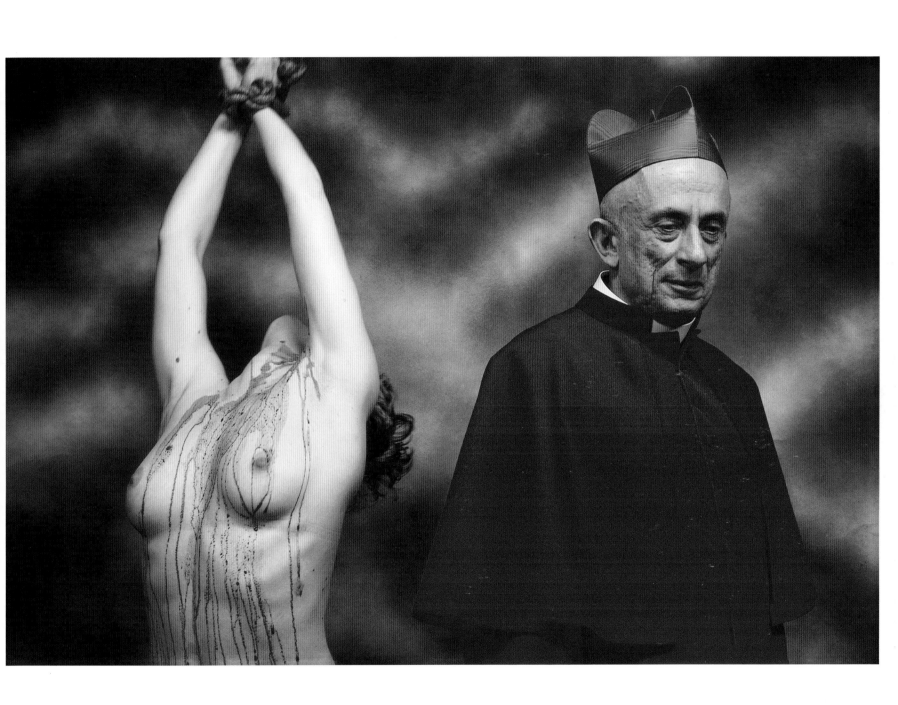

Heaven and Hell, 1984

Milk, Blood, 1986

Milk, 1987

Piss, 1987

Blood, 1987

Yellow River, 1987

Female Bust, 1988

Madonna and Child, 1987

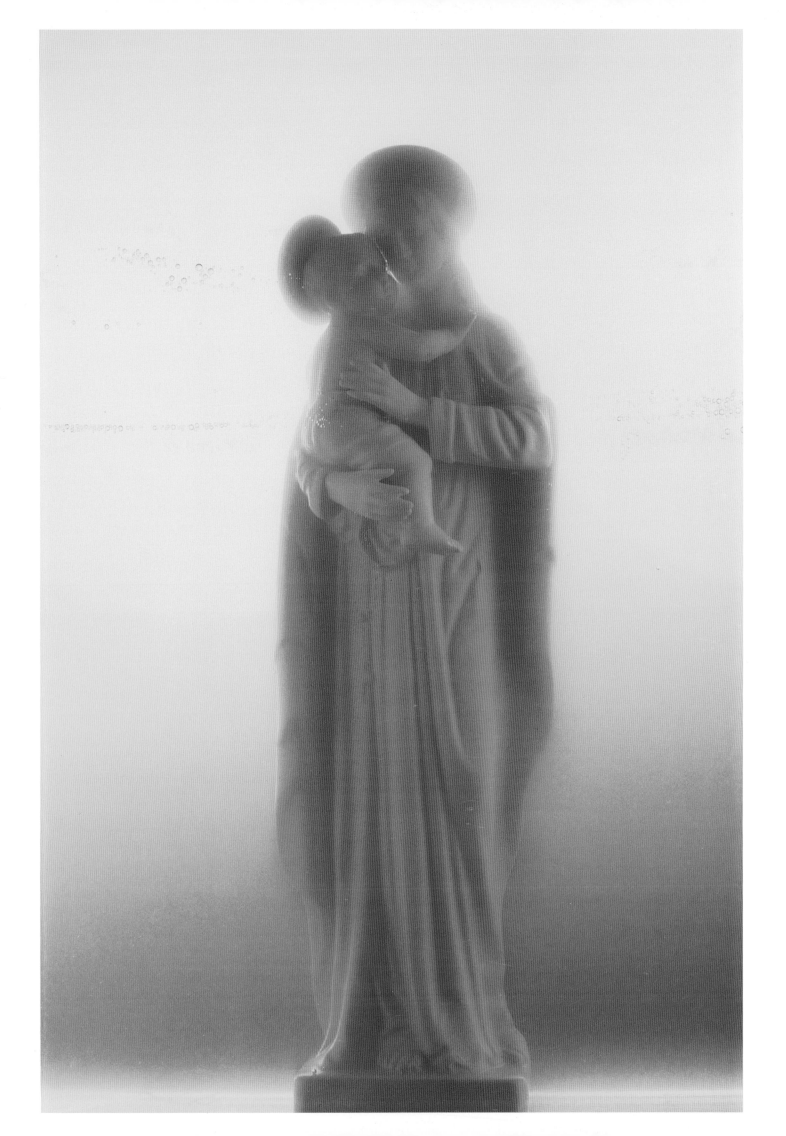

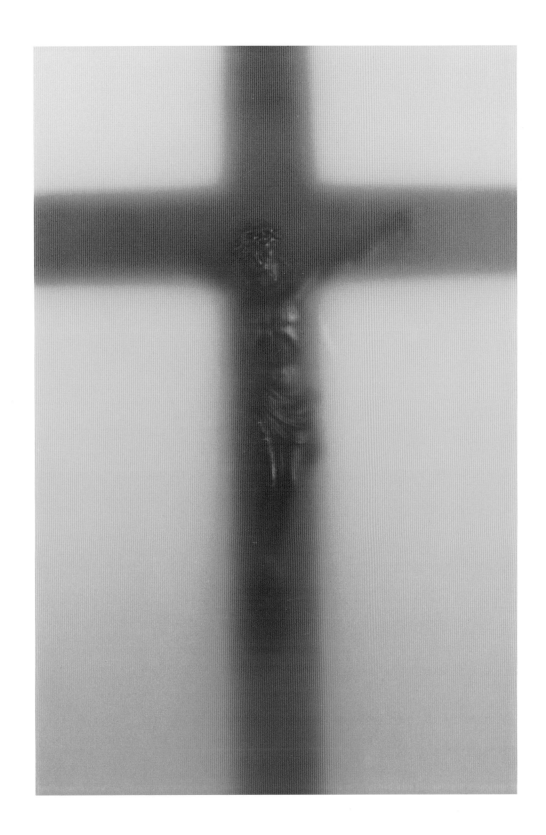

Piss Light, 1987

Opposite page **Winged Victory**, 1987

Piss Christ, 1987

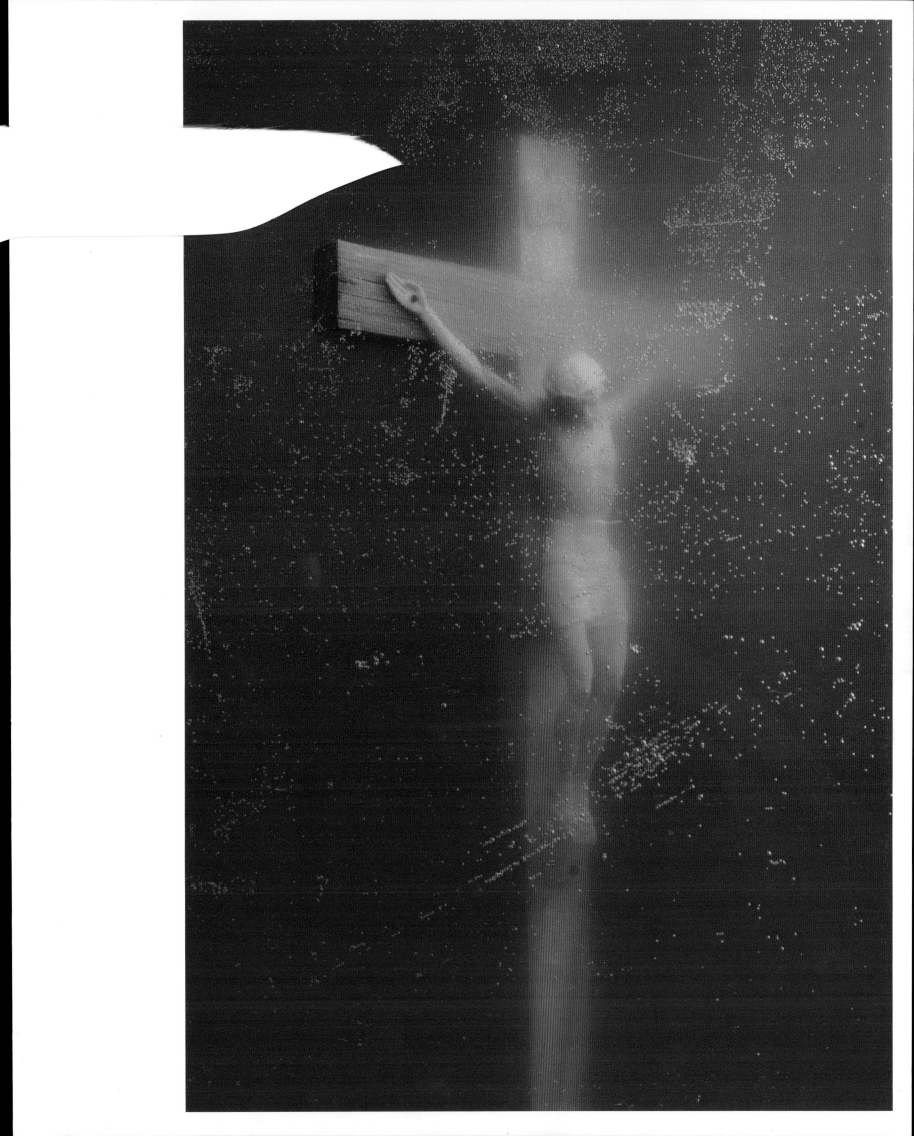

Bloodscape IX, 1989

Crucifixion, 1987

Madonna and Child II, 1989

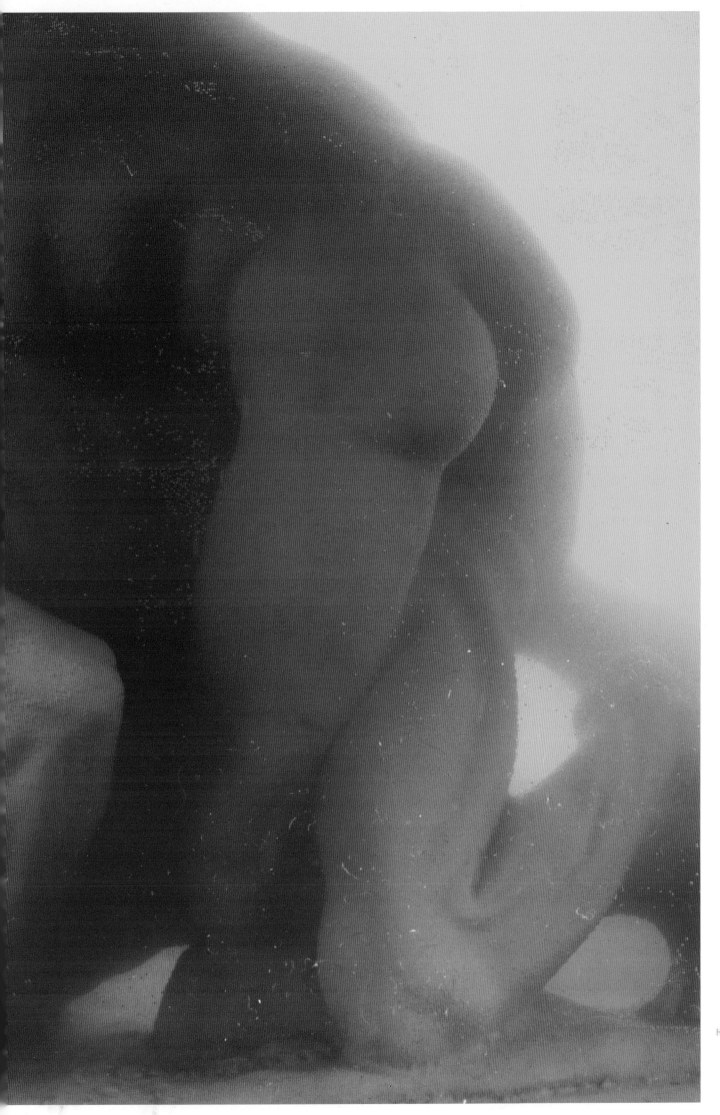

Hercules Punishing Diomedes

Parts I and II 1990

Red Pope, Part III, 1990

St. Michael's Blood, Parts I and II, 1990

Precious Blood, 1989

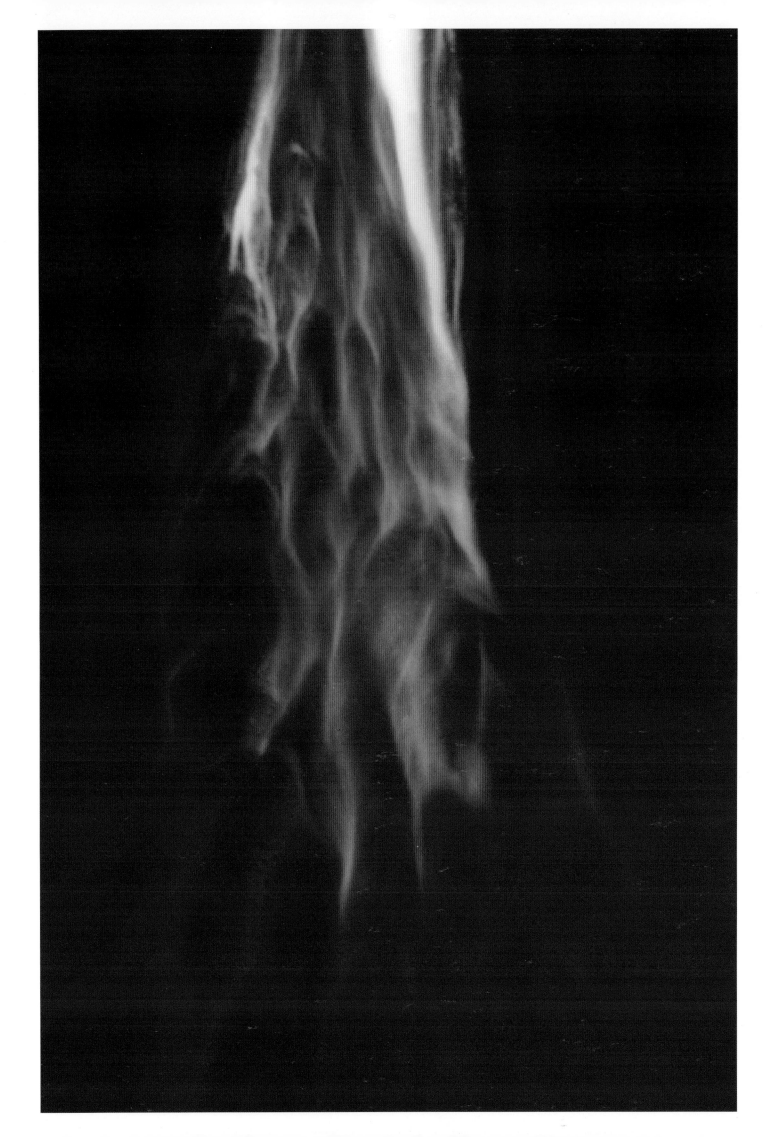

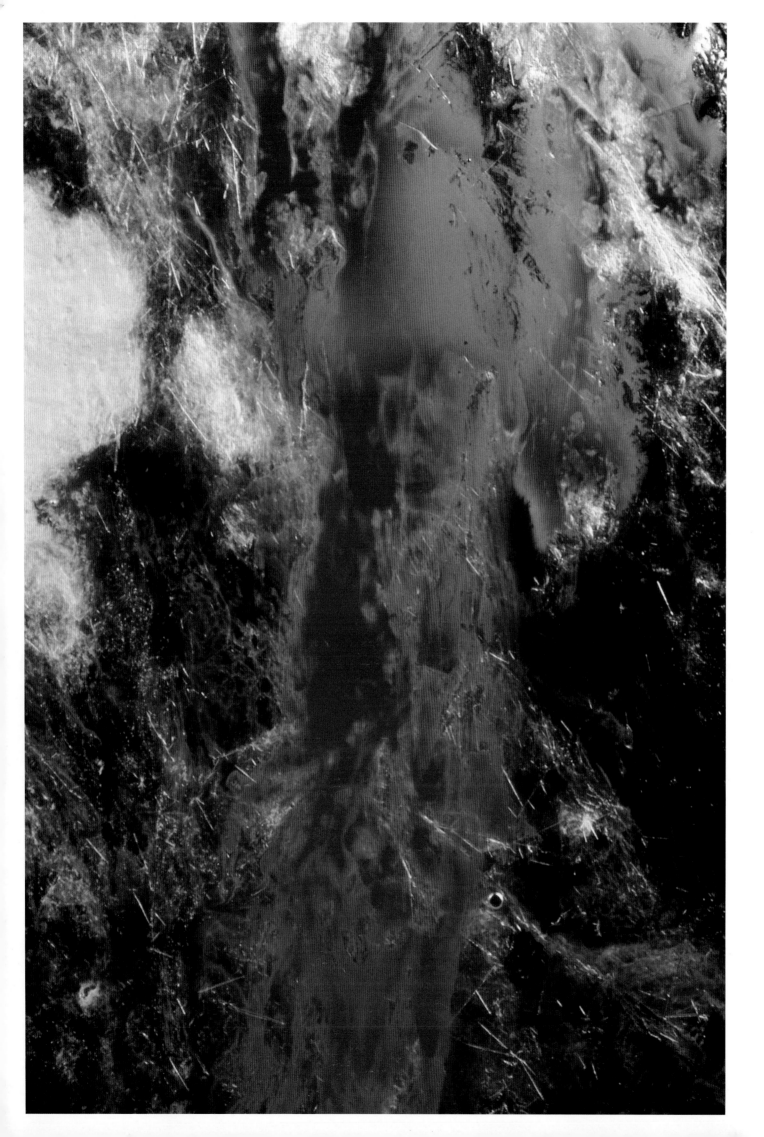

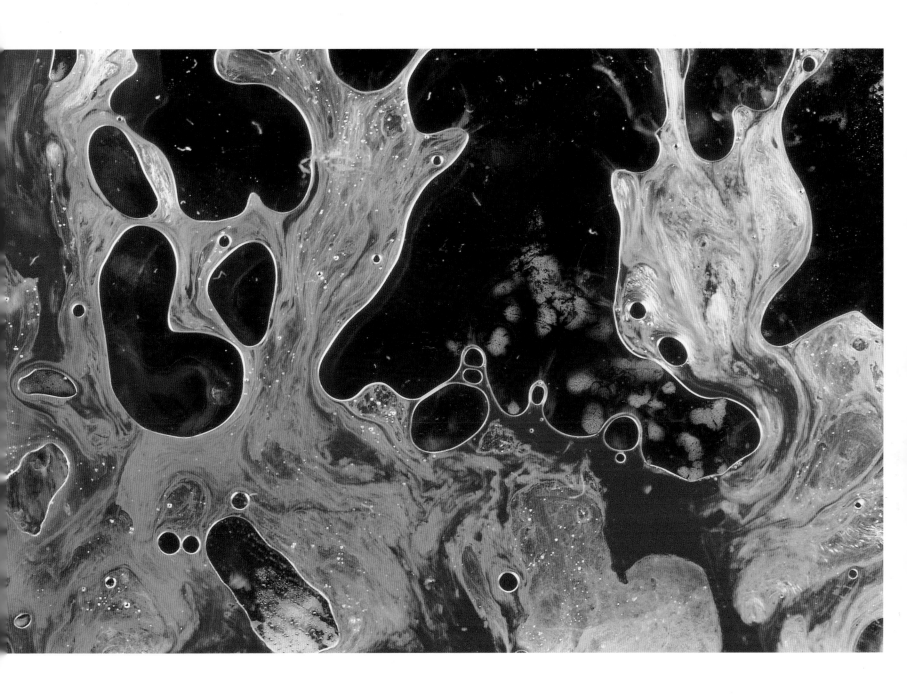

Semen and Blood III, 1990

Opposite page Frozen Semen With Blood, 1990

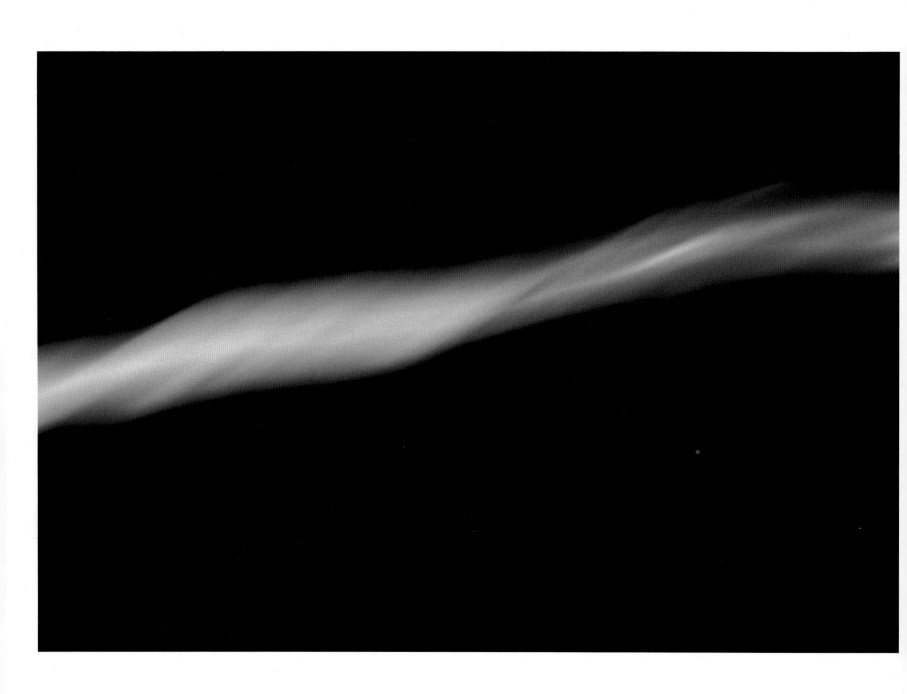

Untitled XIV (Ejaculate in Trajectory), 1989

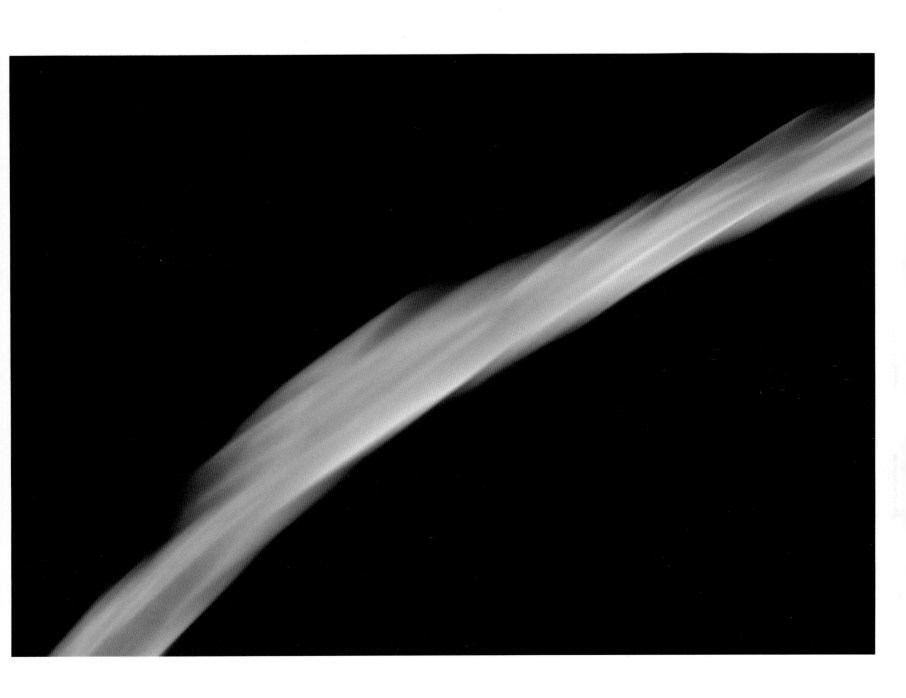

Untitled VII (Ejaculate in Trajectory), 1989

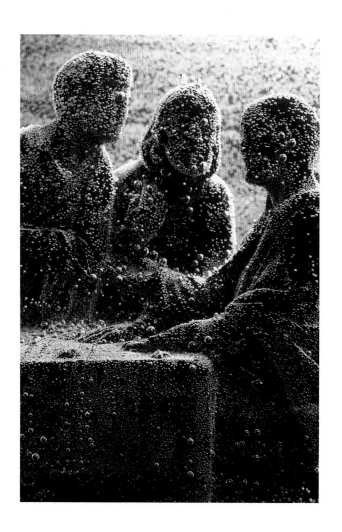

Black Supper (V), 1990

Opposite page **Black Supper** (II), 1990

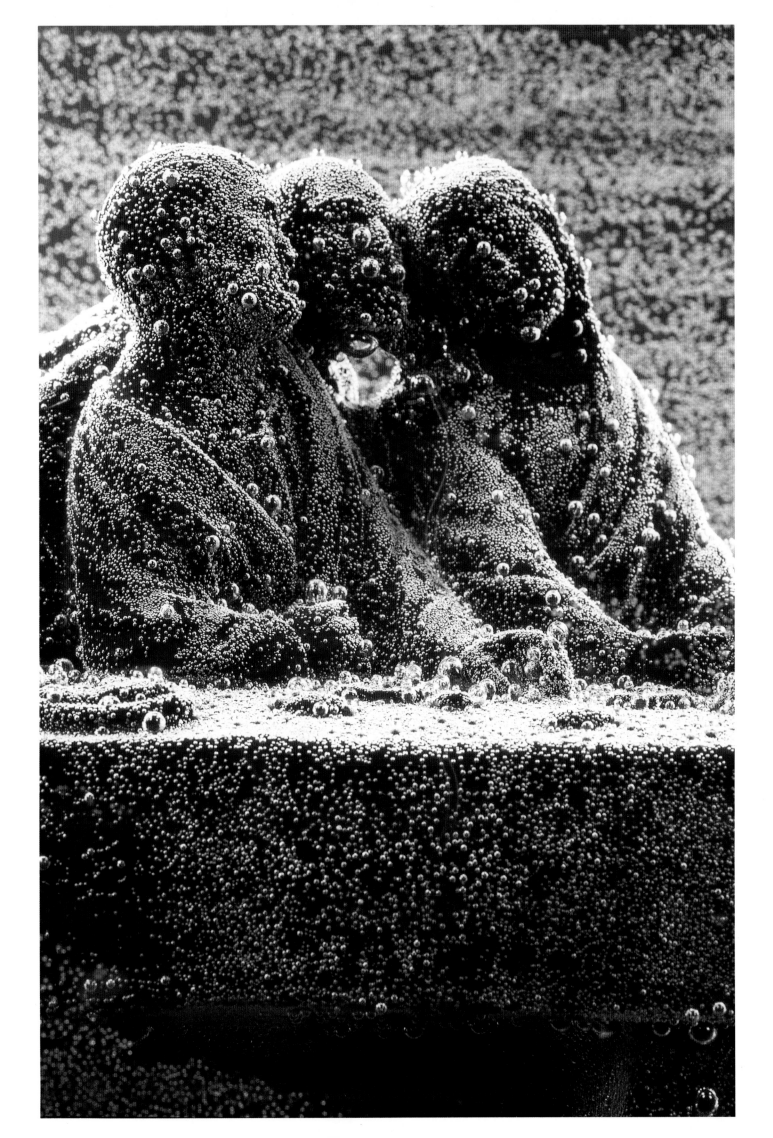

Black Mary, 1990

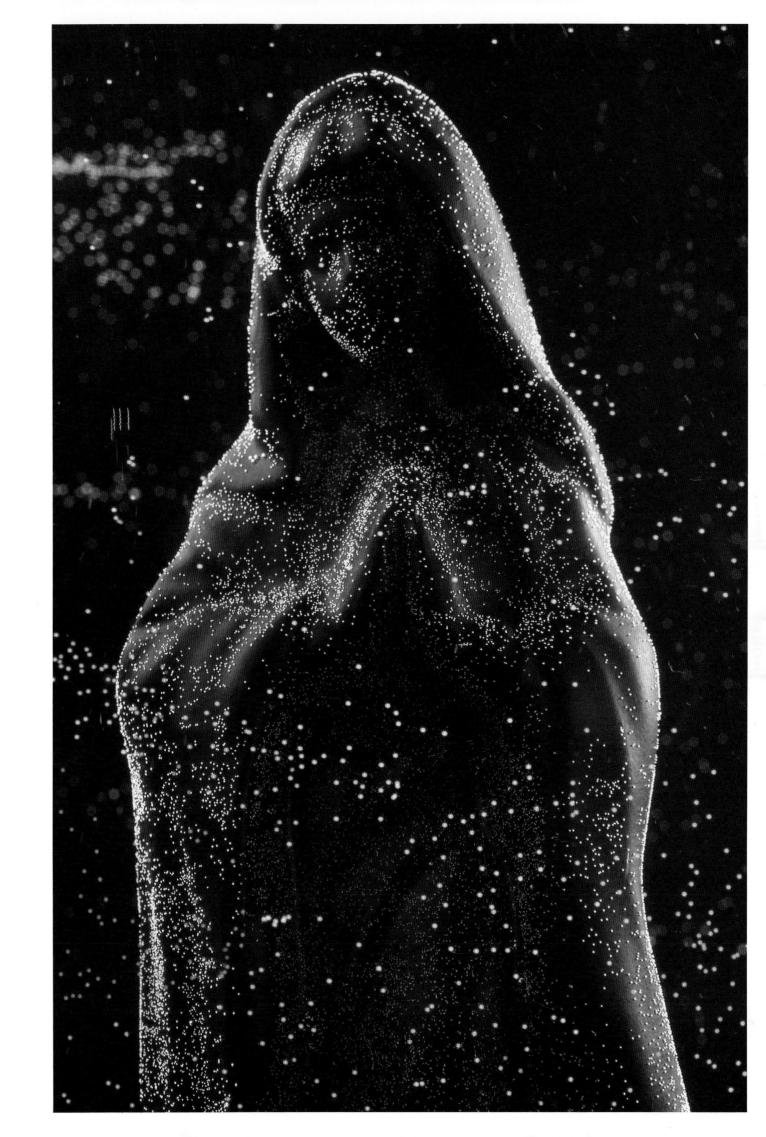

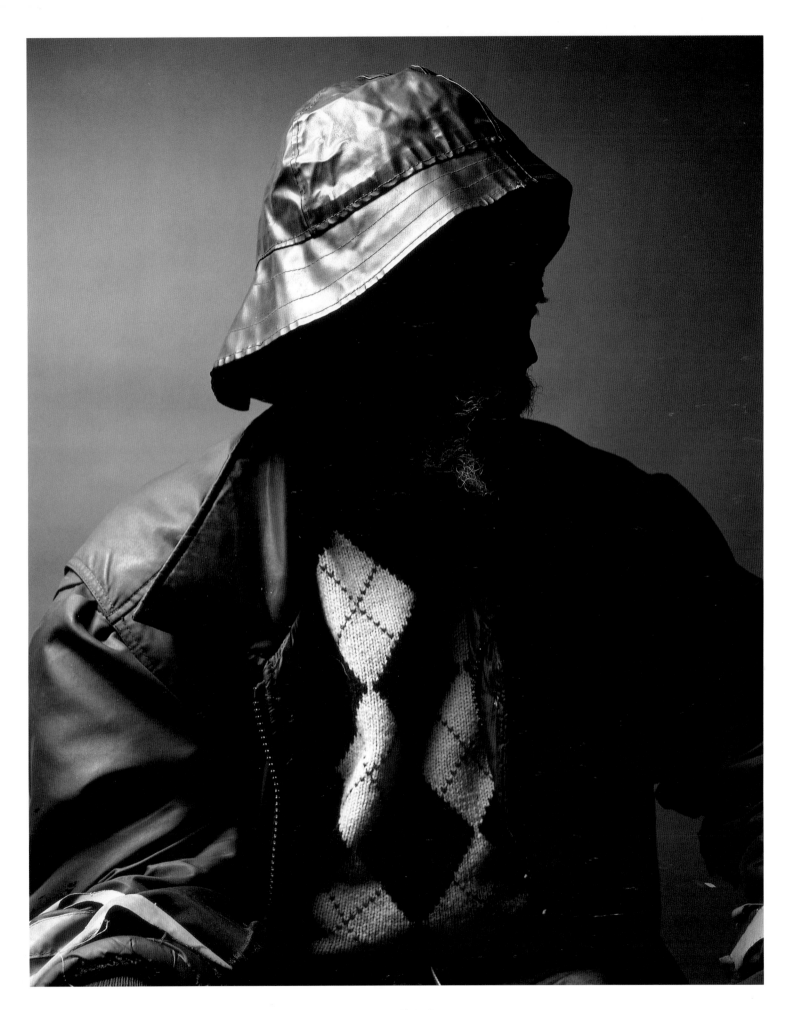

Nomads (McKinley), 1990

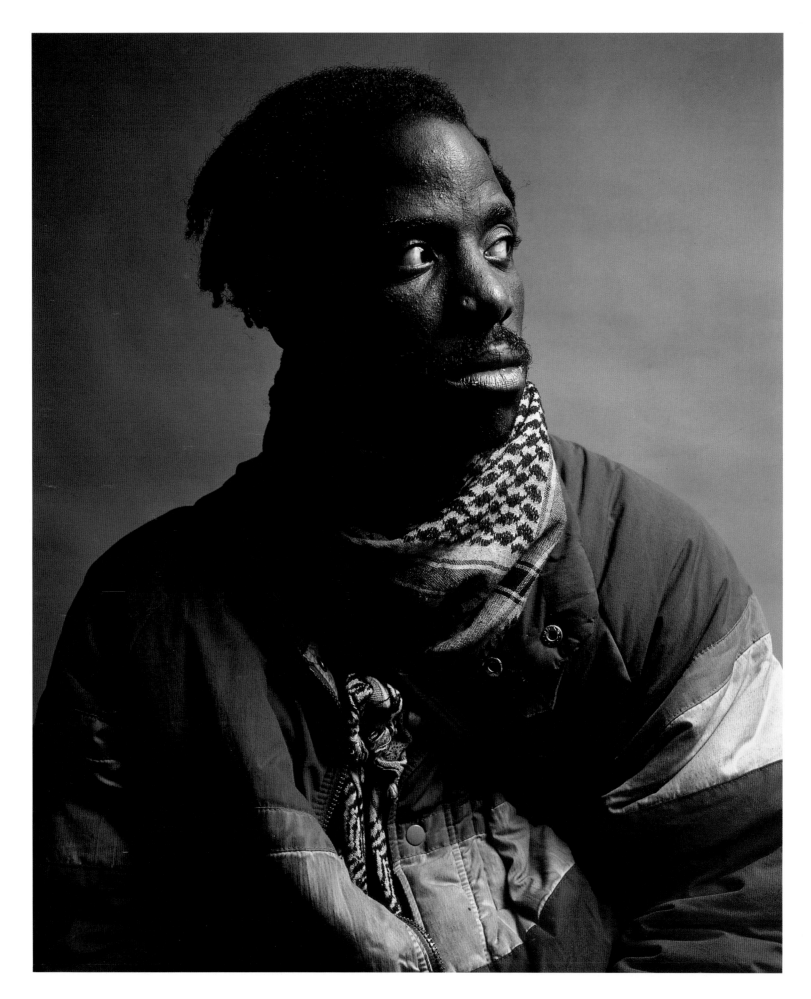

Nomads (René), 1990

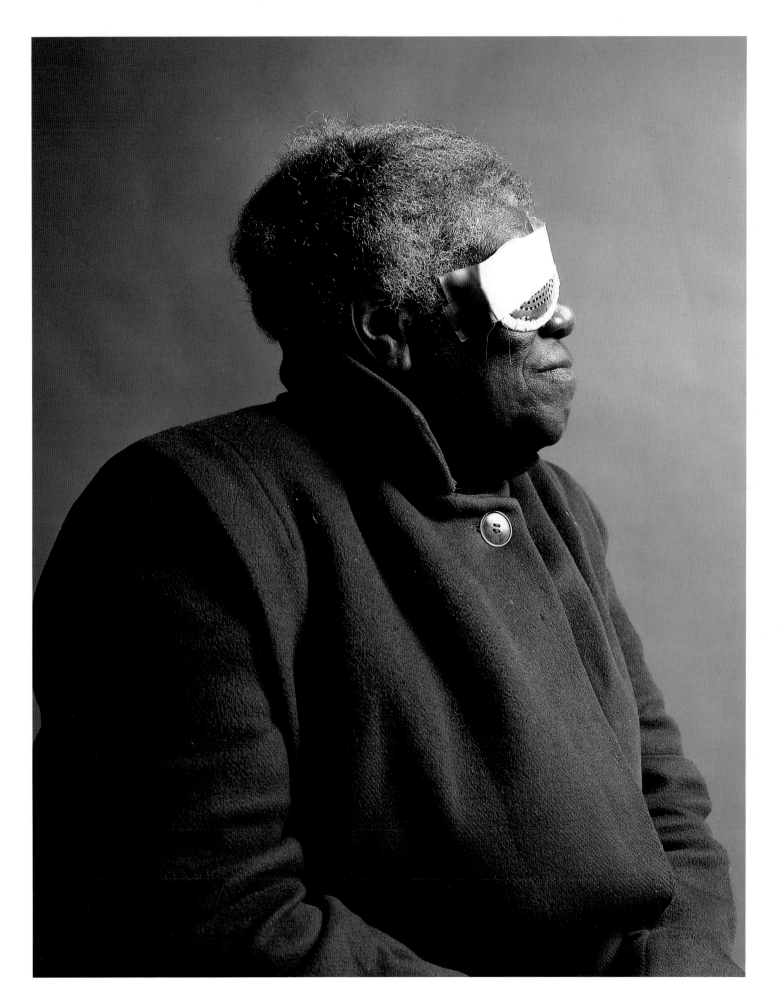

Nomads (Gussie), 1990

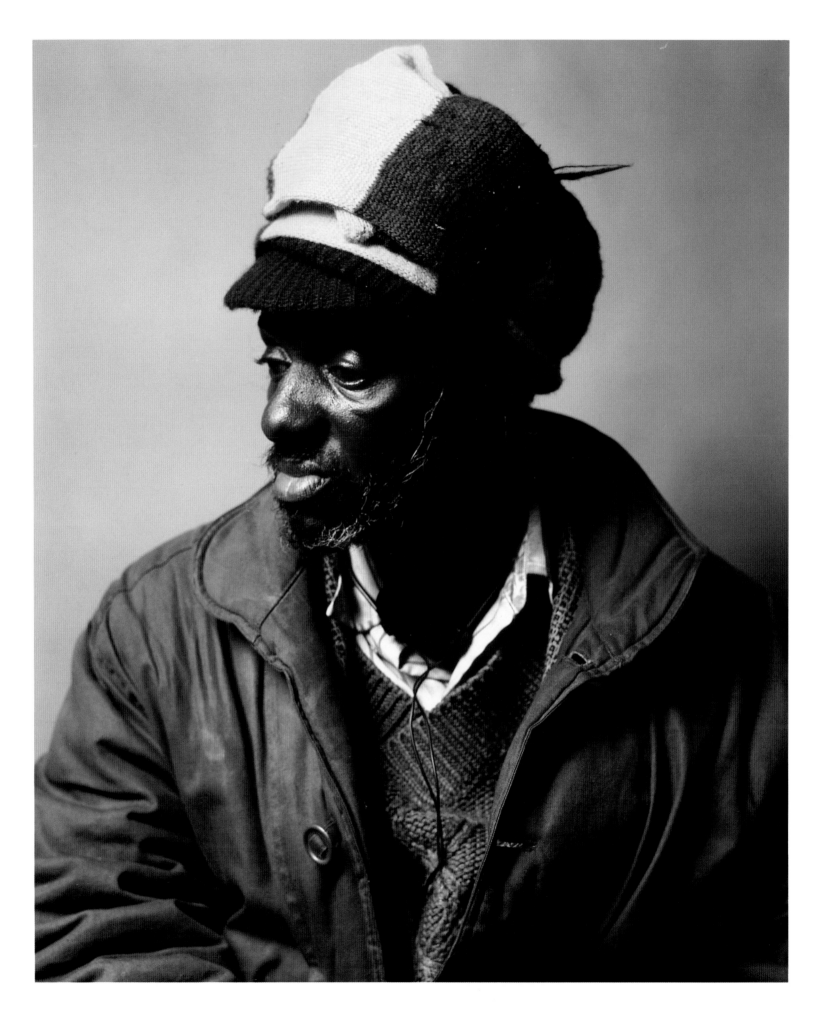

Nomads (Gator), 1990

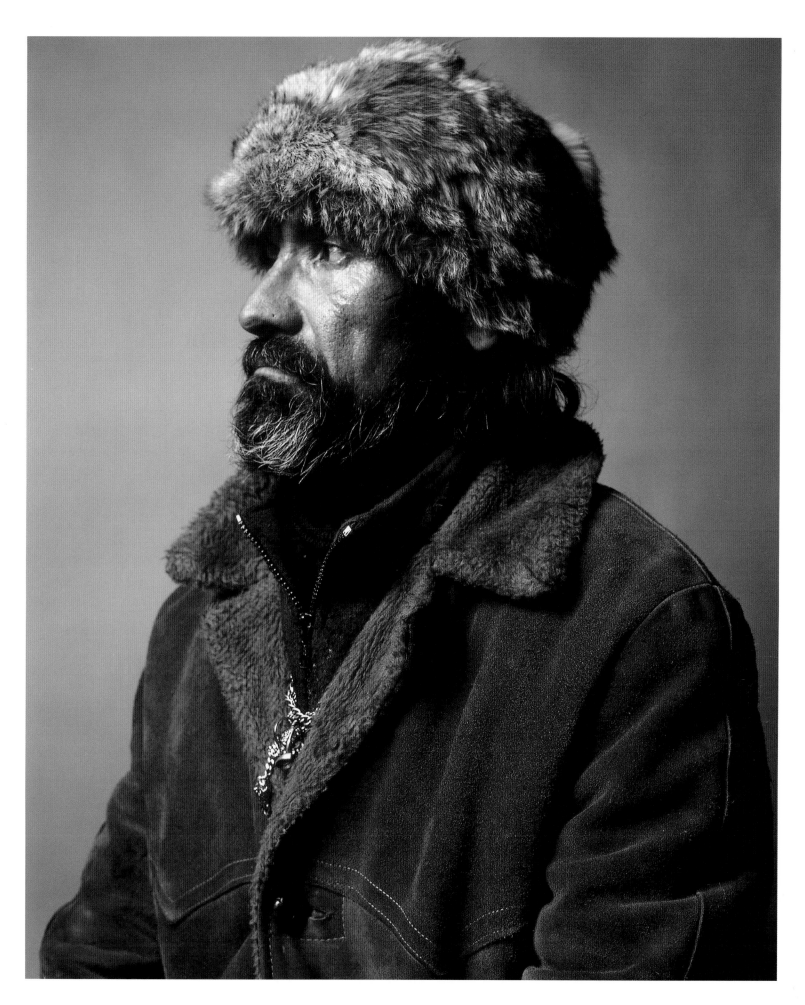

Nomads (Johnny), 1990

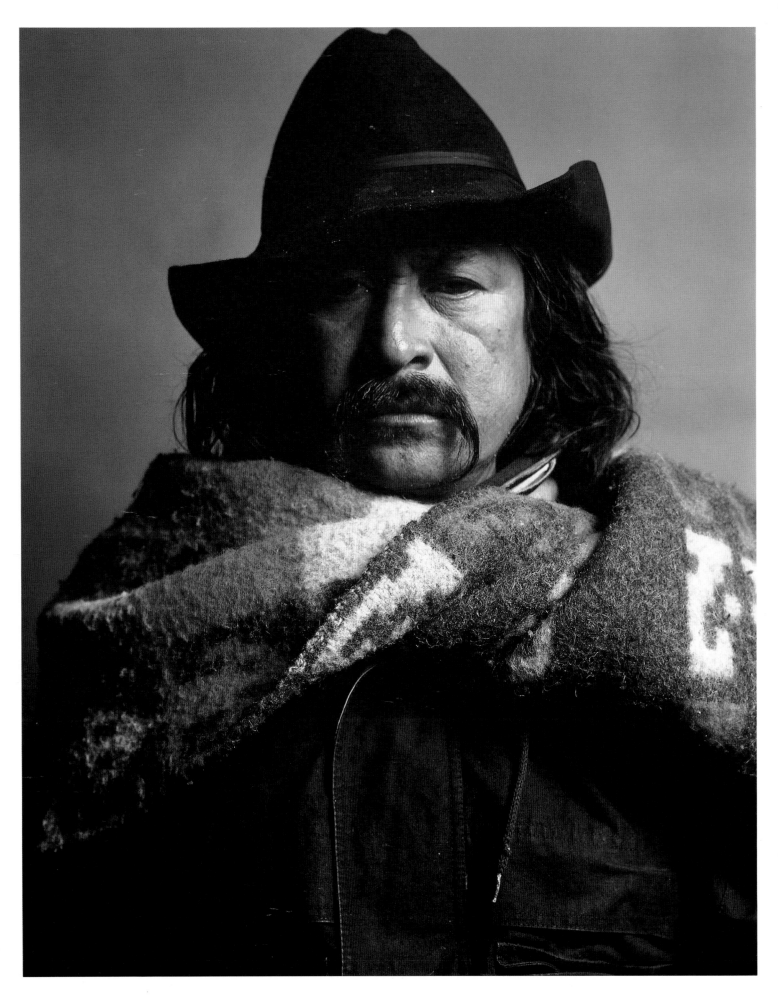

Nomads (Lucas), 1990

Klanswoman (Grand Klaliff II), 1990

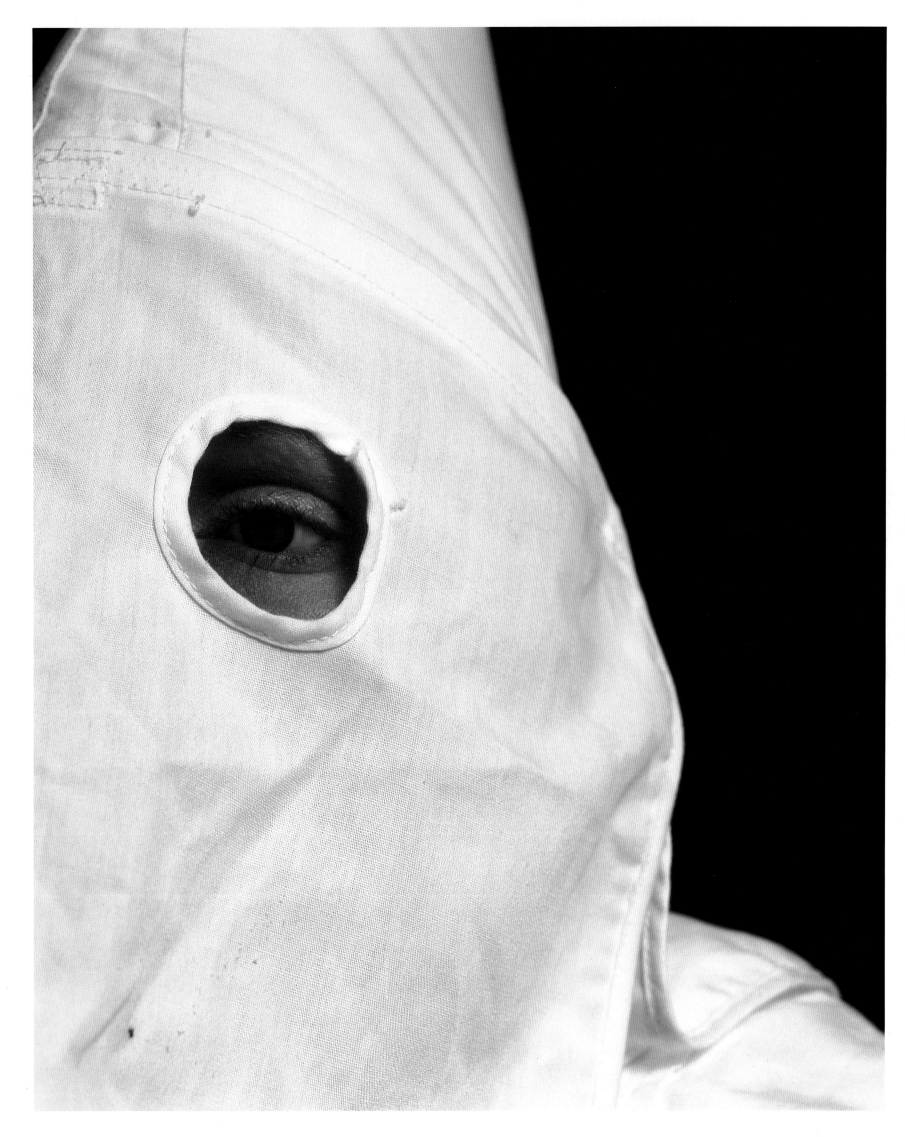

Klansman (Imperial Wizard), 1990

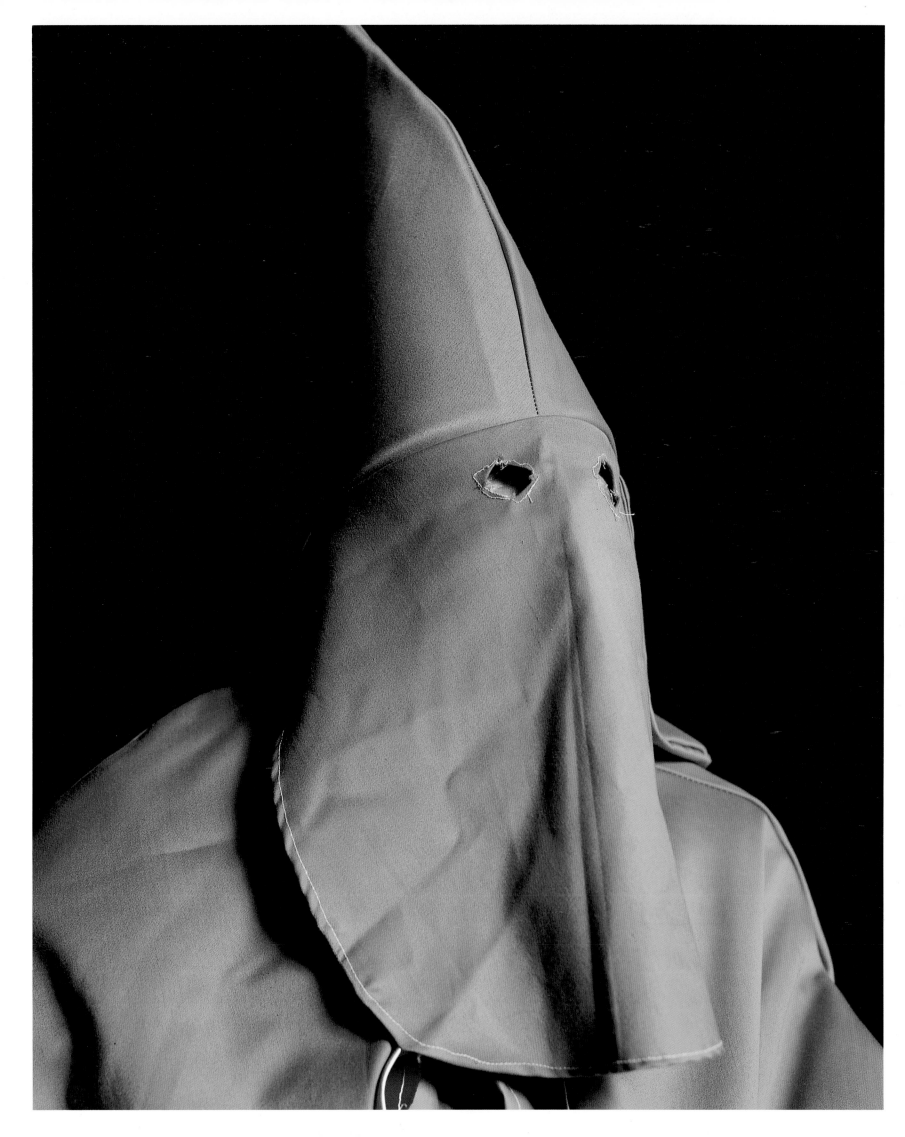

Klansman (Great Titan of the Invisible Empire), 1990

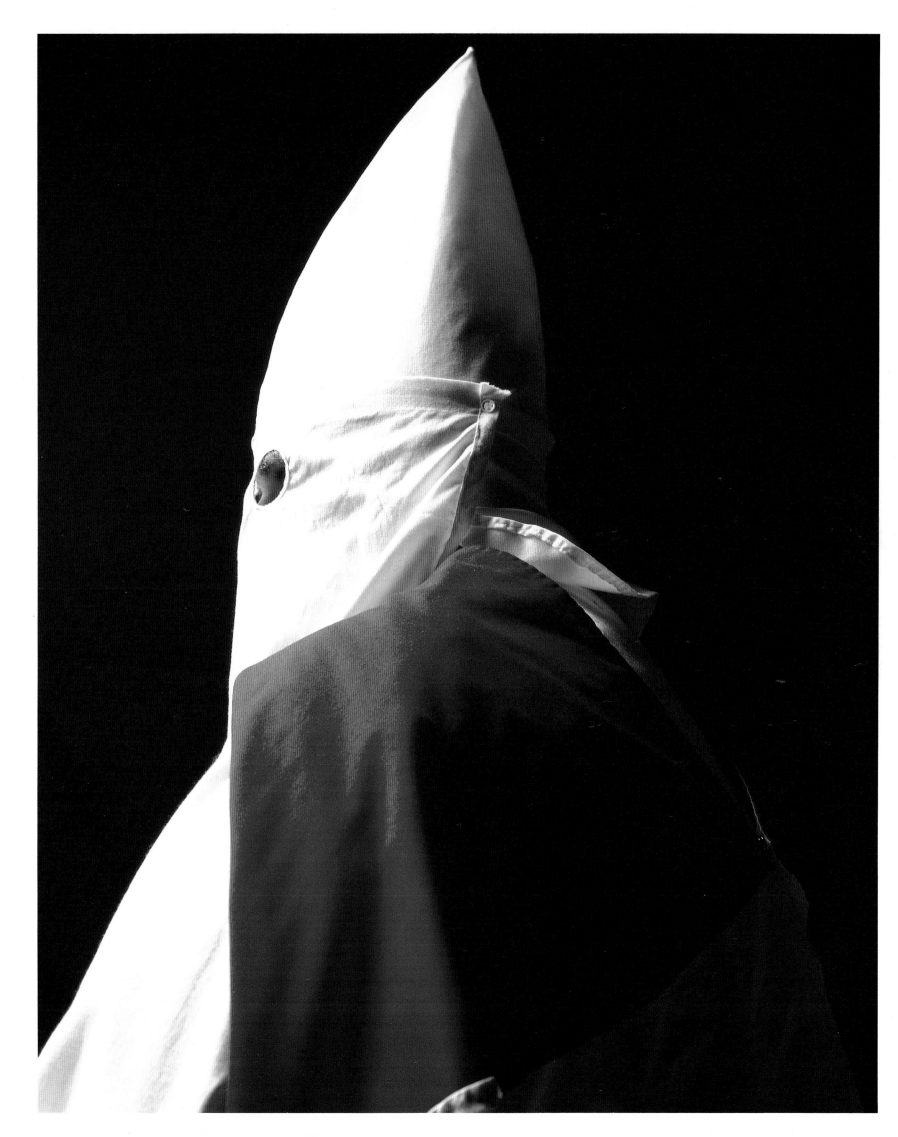

Klansman (Knight Hawk of Georgia IV), 1990

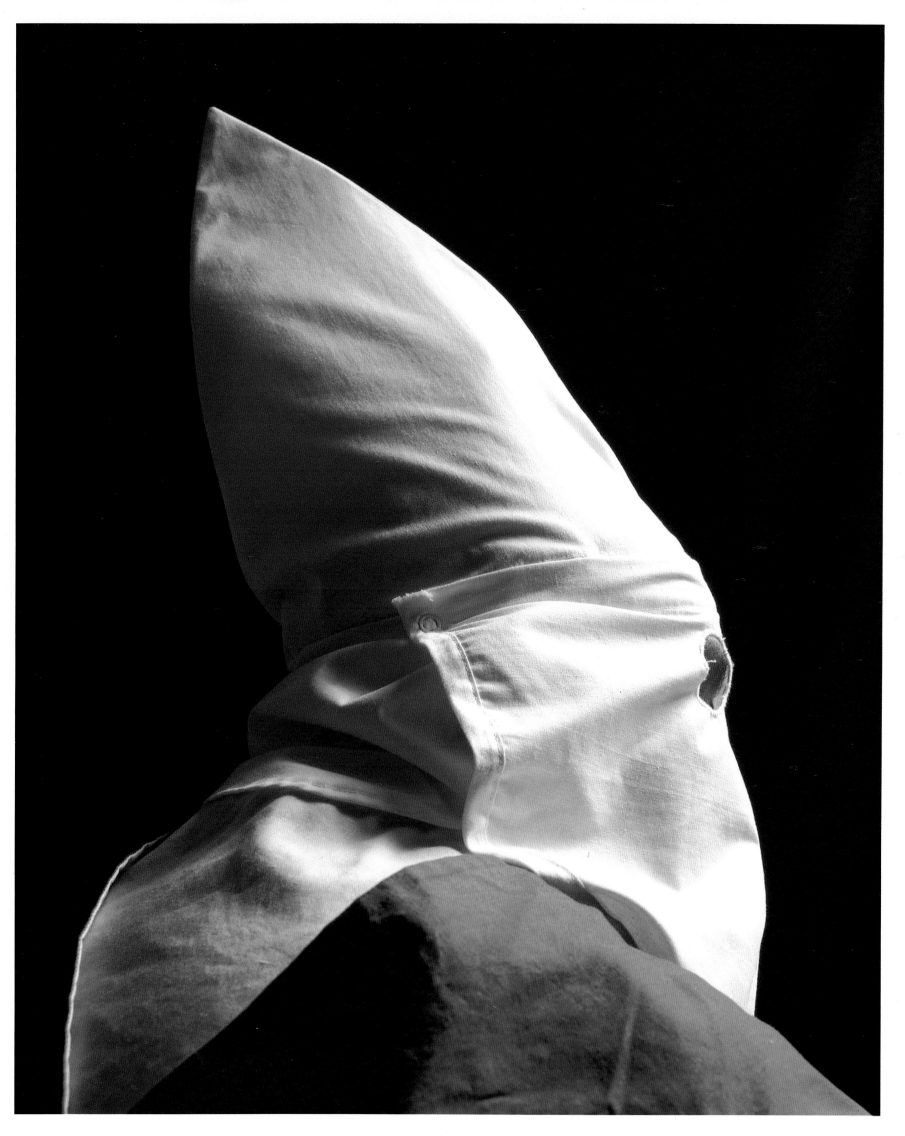

Klansman (Imperial Wizard II), 1990

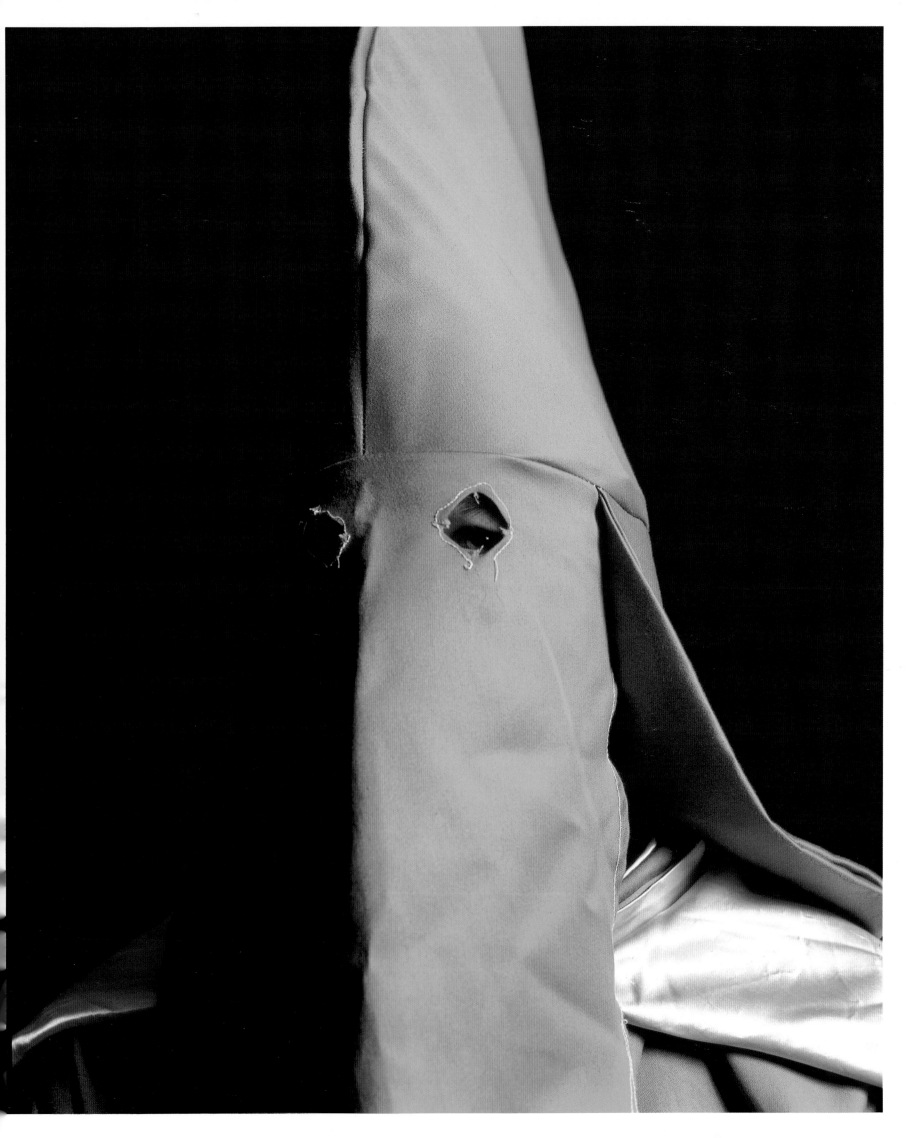

Klanswoman (Grand Klaliff), 1990

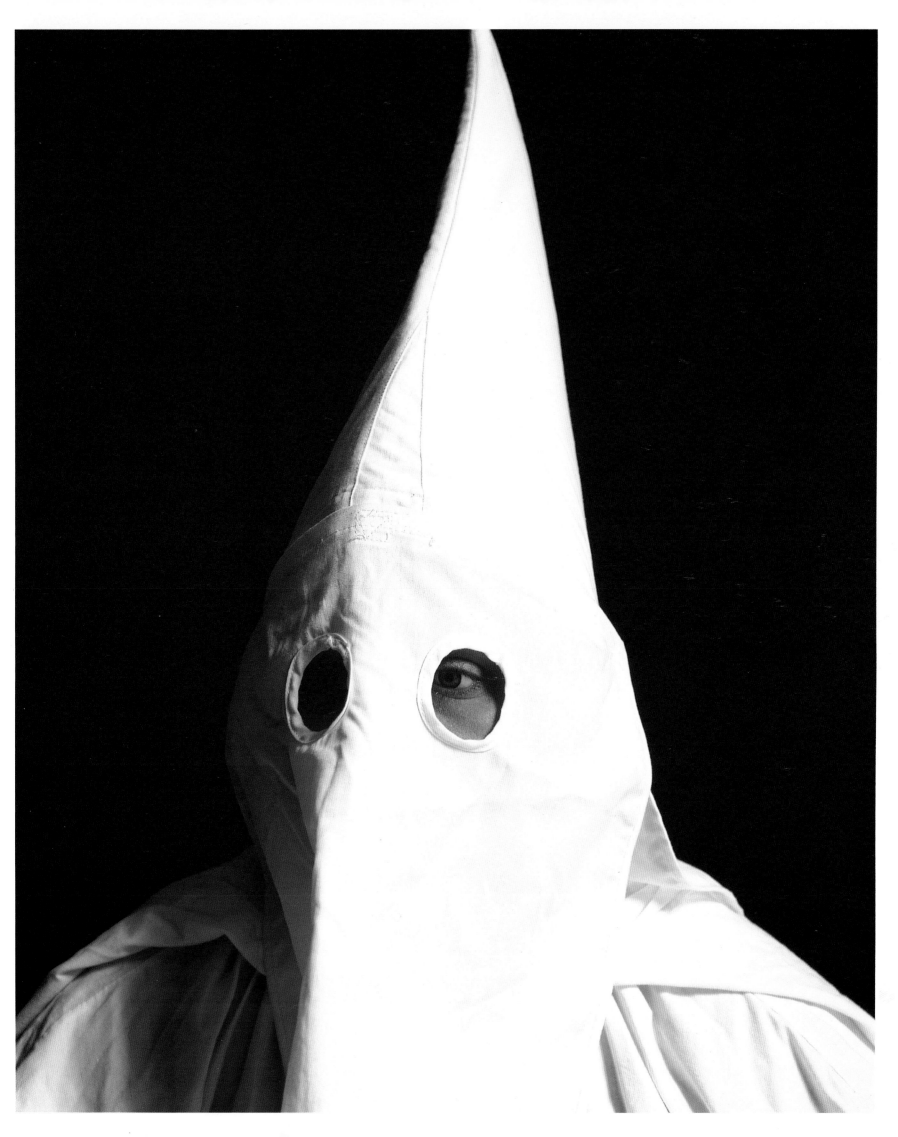

The Church (Frari Paolo), 1991

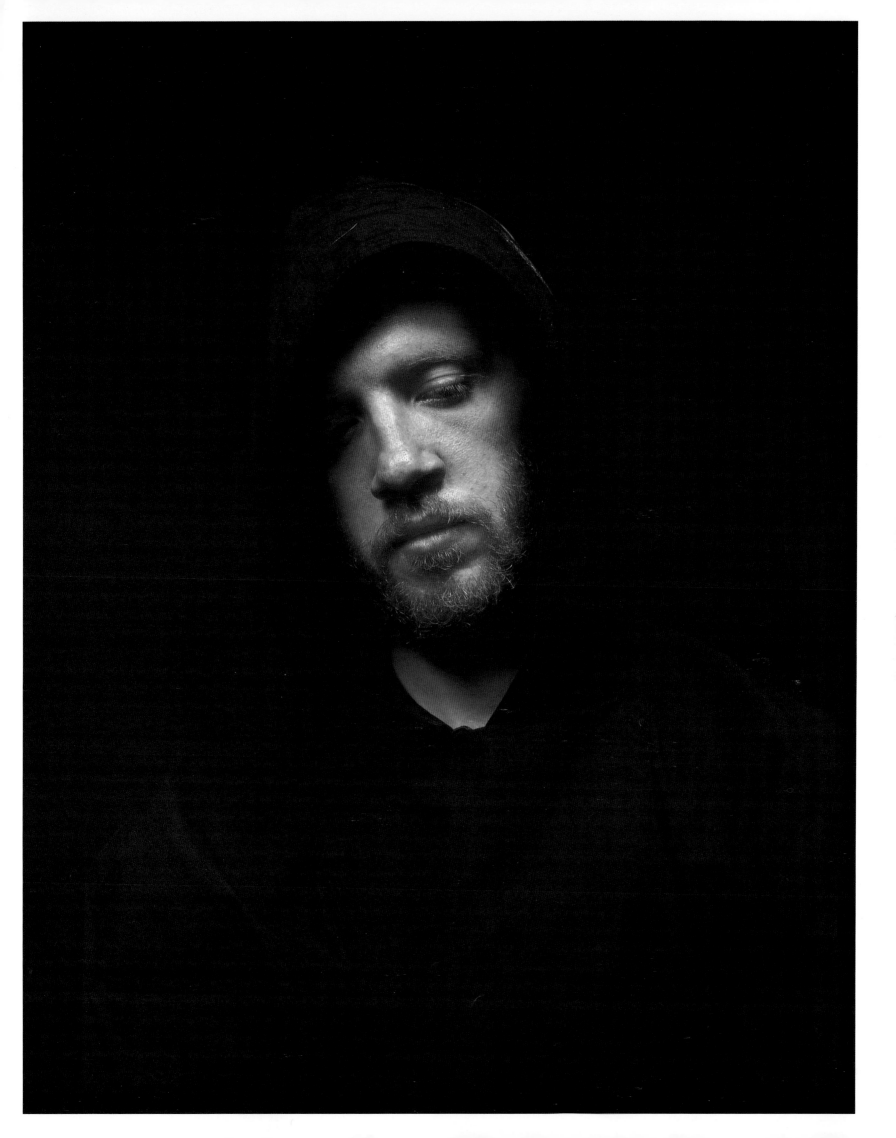

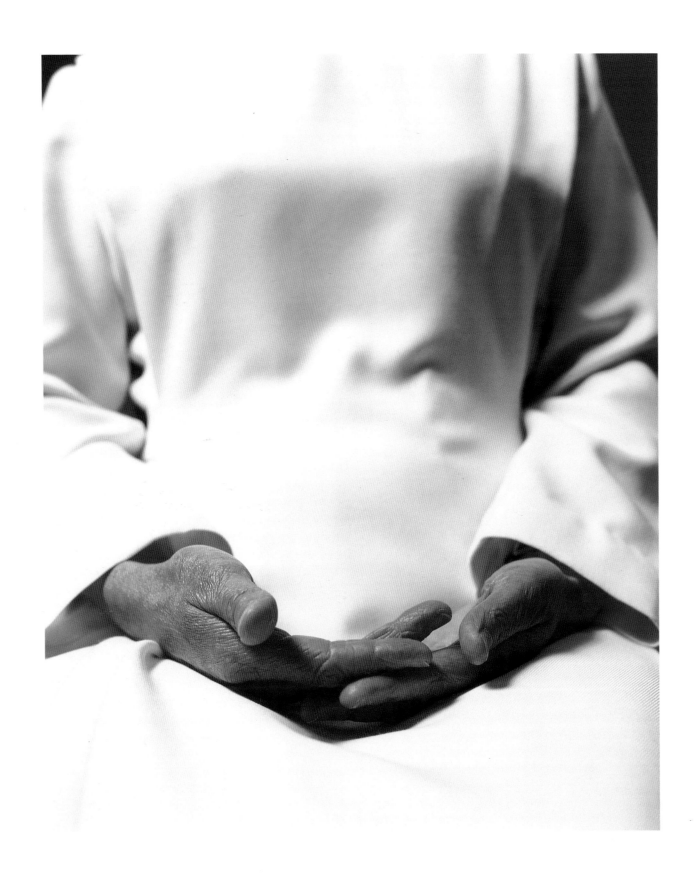

The Church (Soeur Jeanne Miriam), 1991

The Church (St. Clotilde, Paris), 1991

The Church (Soeur Bozema), 1991

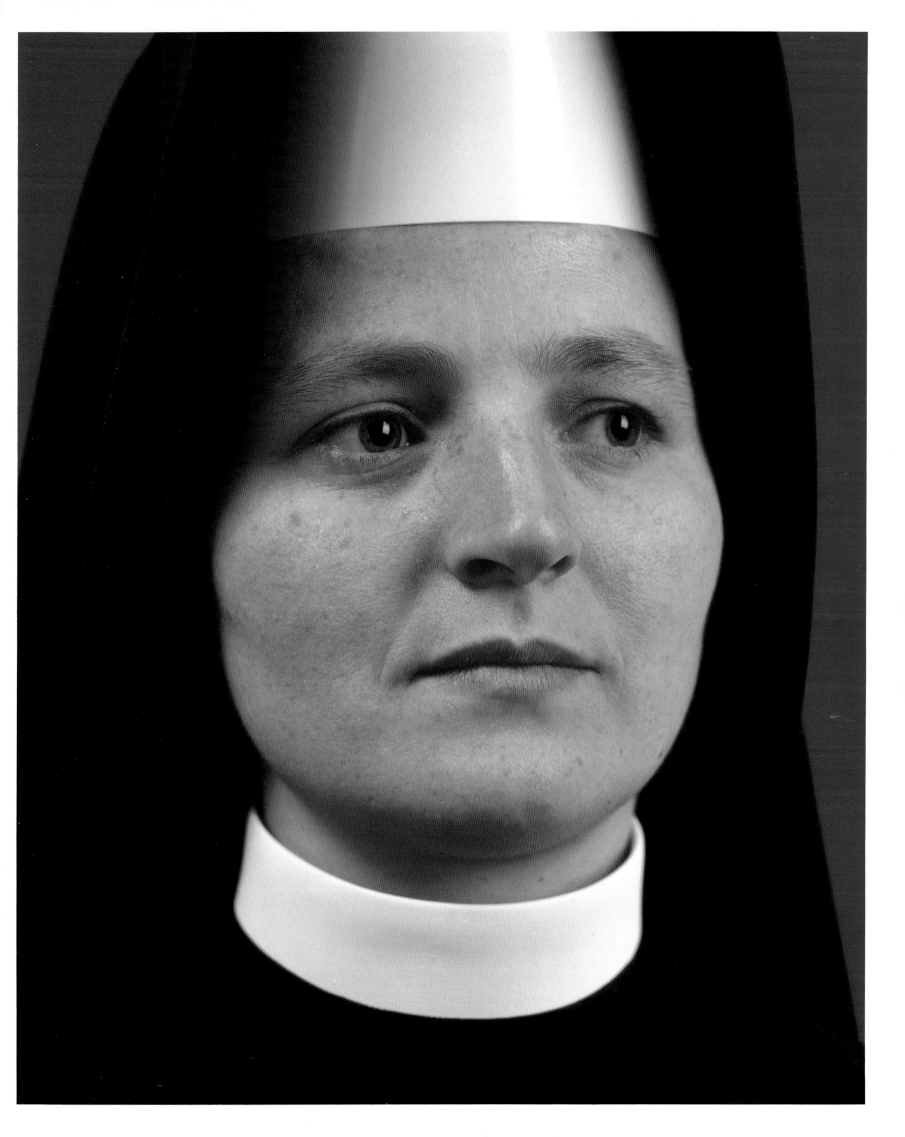

The Church (Padre Giuseppe, Venice), 1991

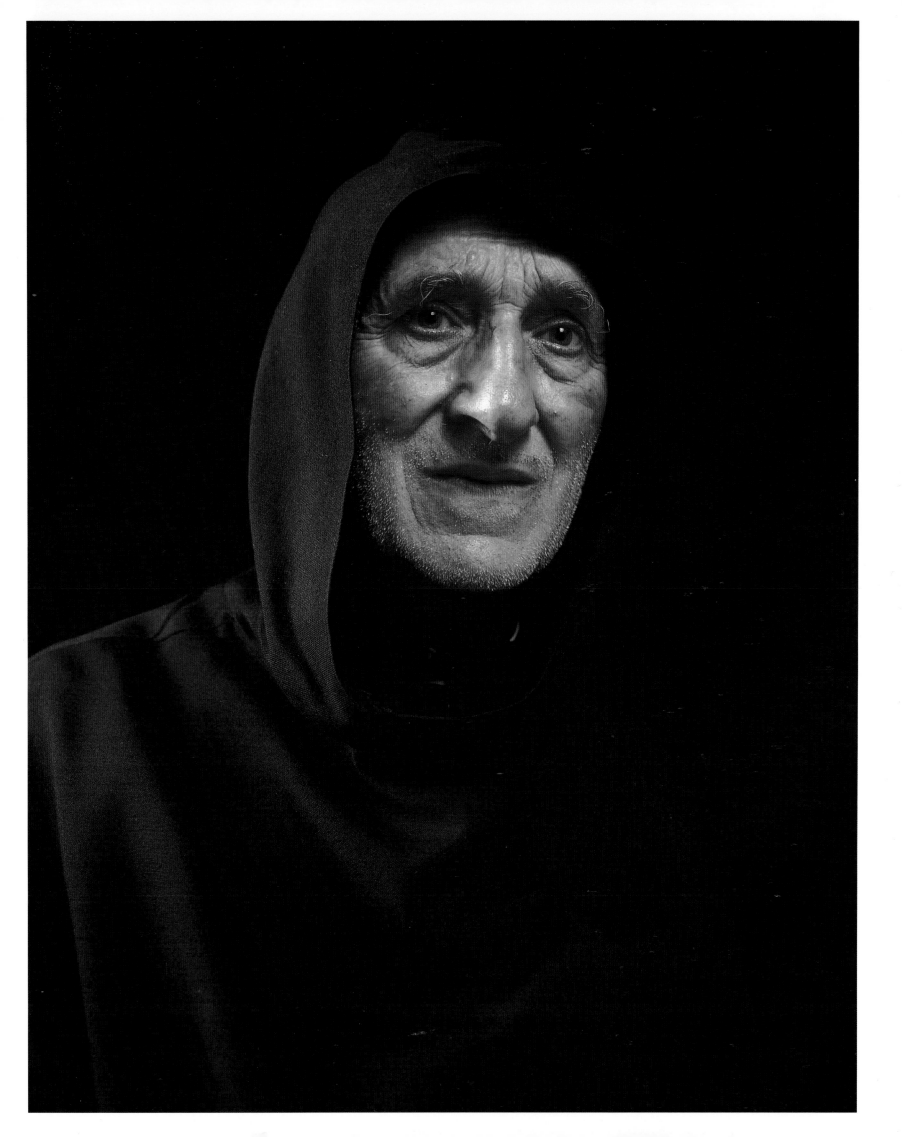

The Church (Saint Eustache II, Paris), 1991

Opposite page The Church (Soeur Yvette II), 1991

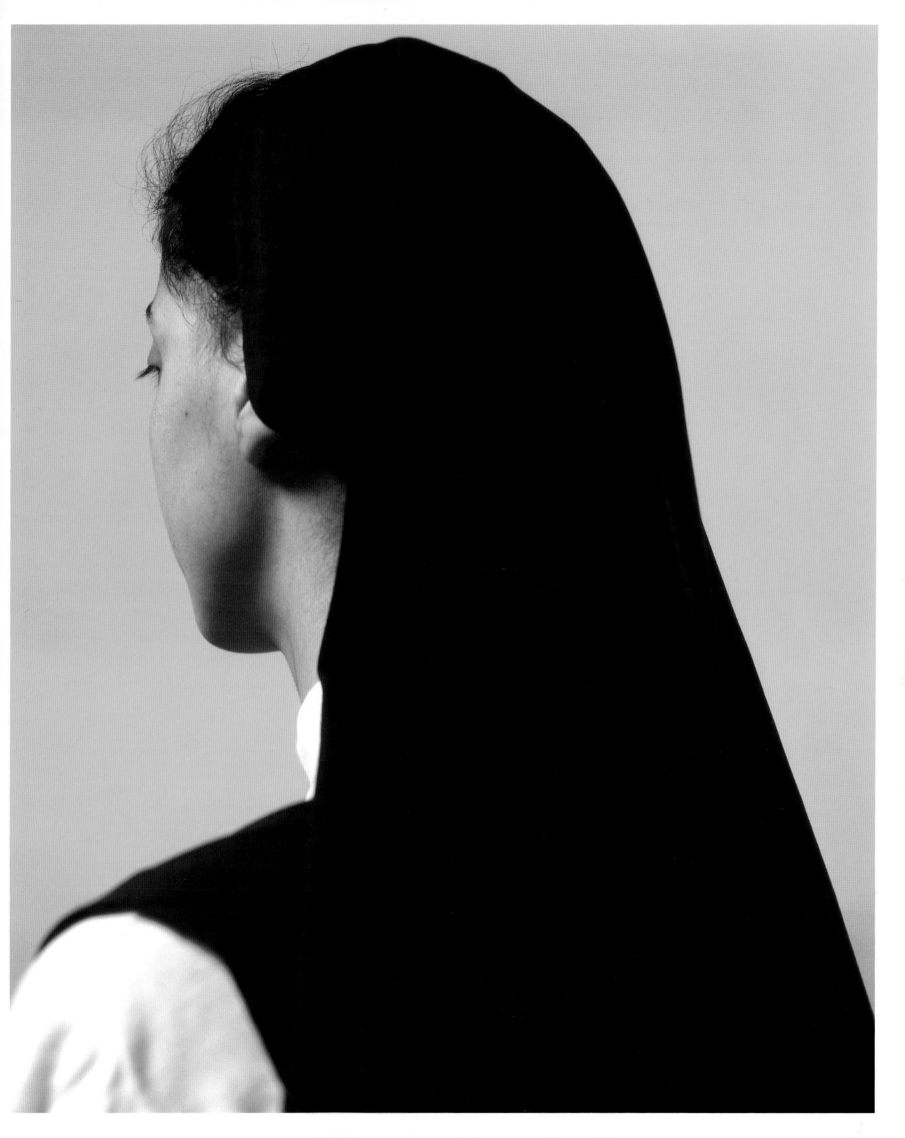

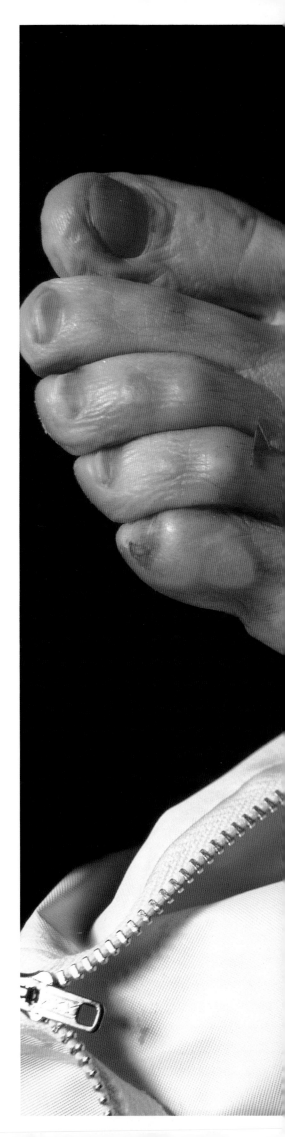

The Morgue (Rat Poison Suicide II), 1992

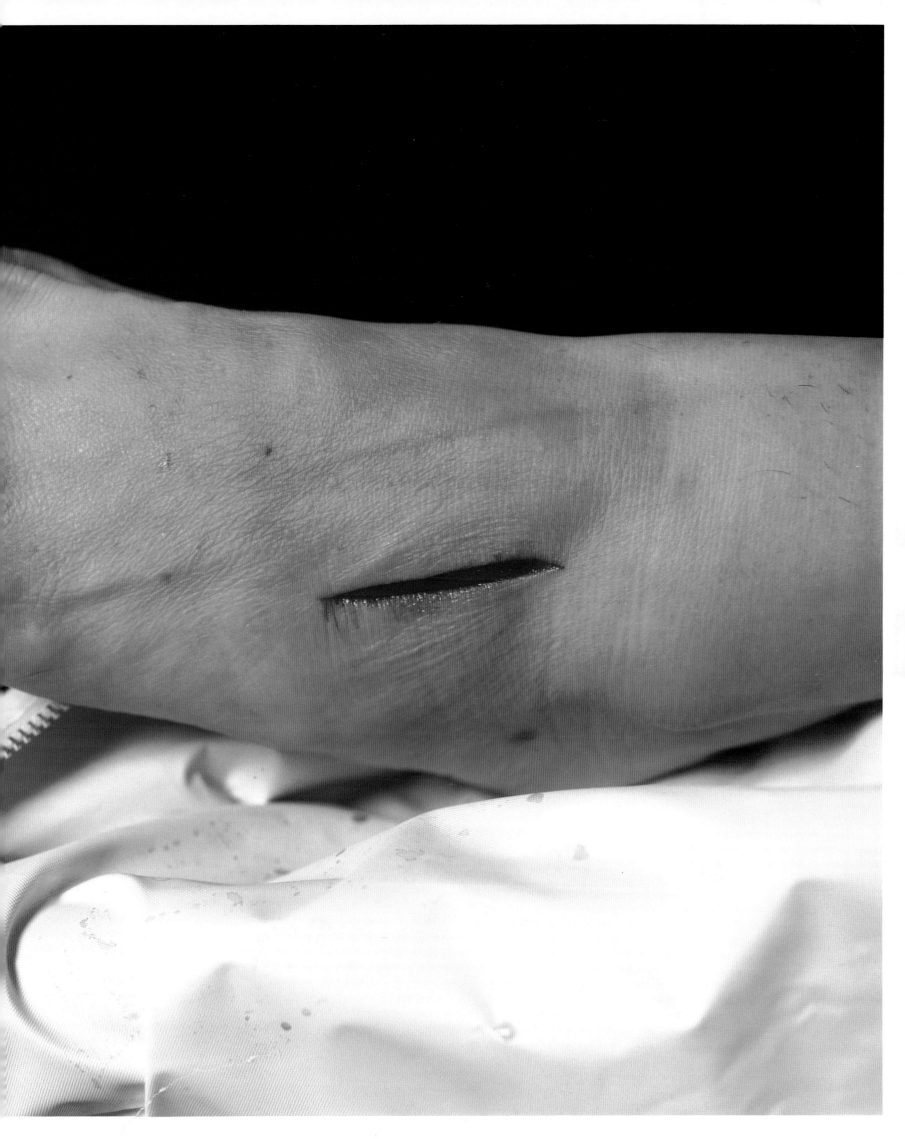

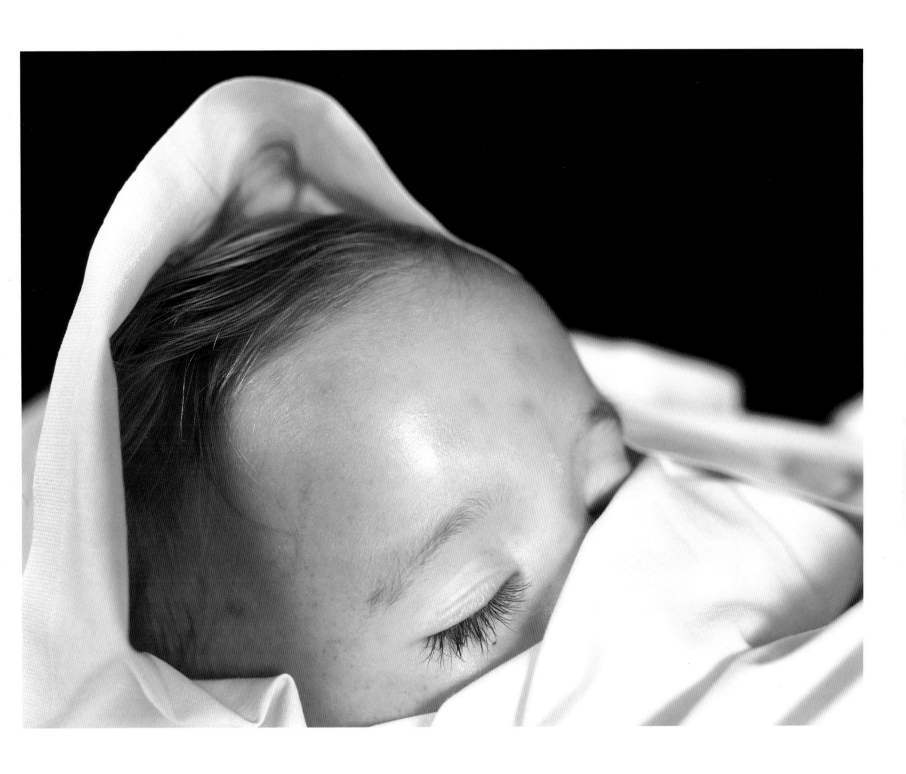

The Morgue (Fatal Meningitis II), 1992

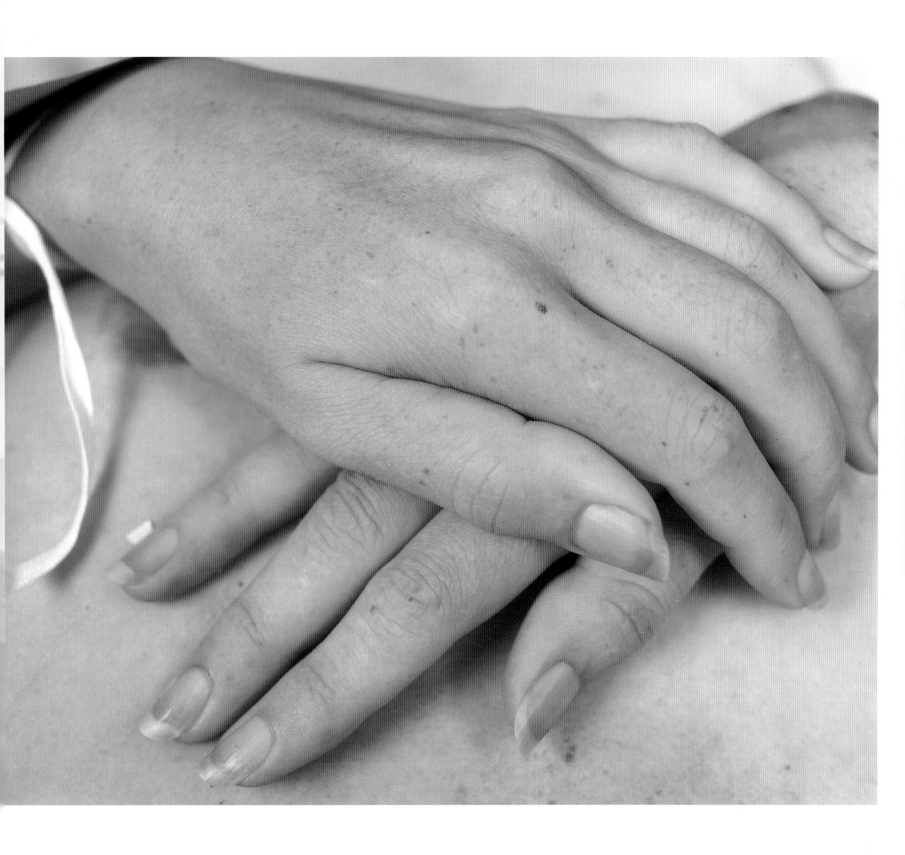

The Morgue (AIDS-Related Death), 1992

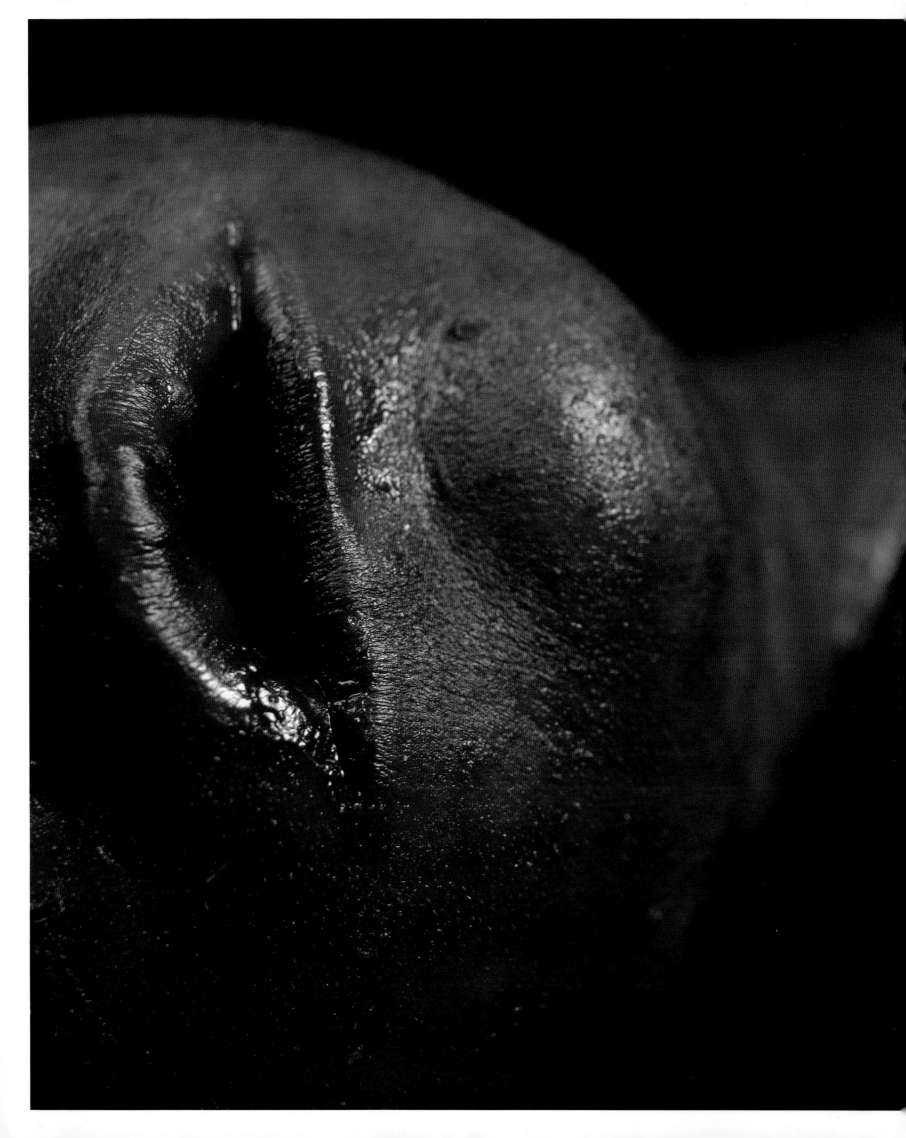

The Morgue (Death By Drowning II), 1992

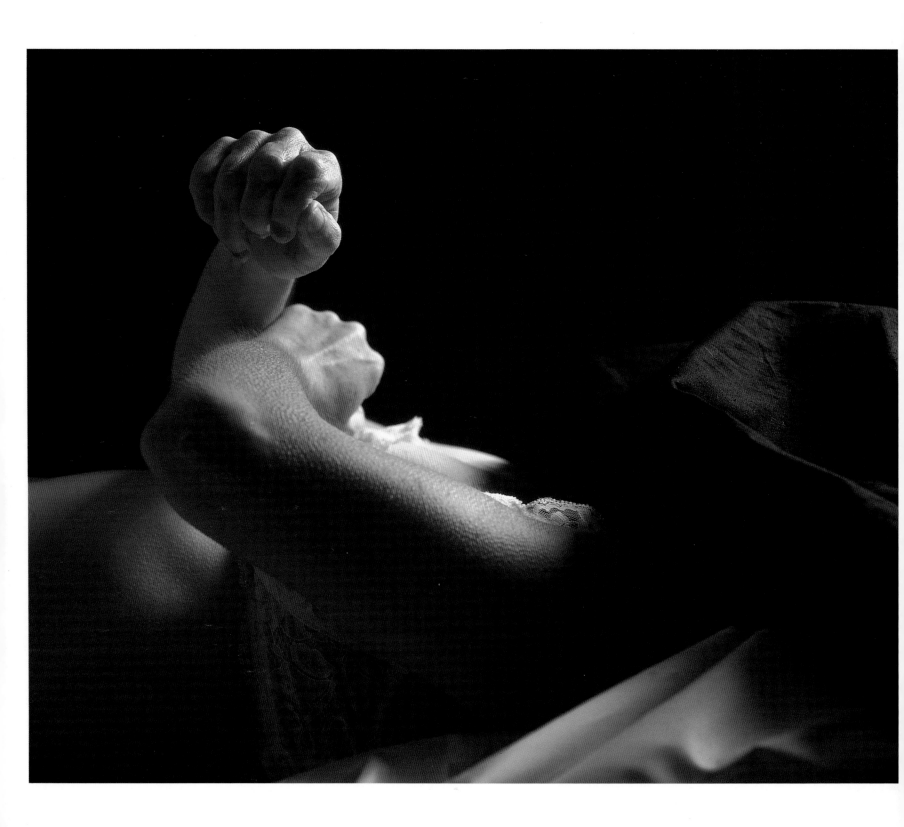

The Morgue (Rat Poison Suicide), 1992

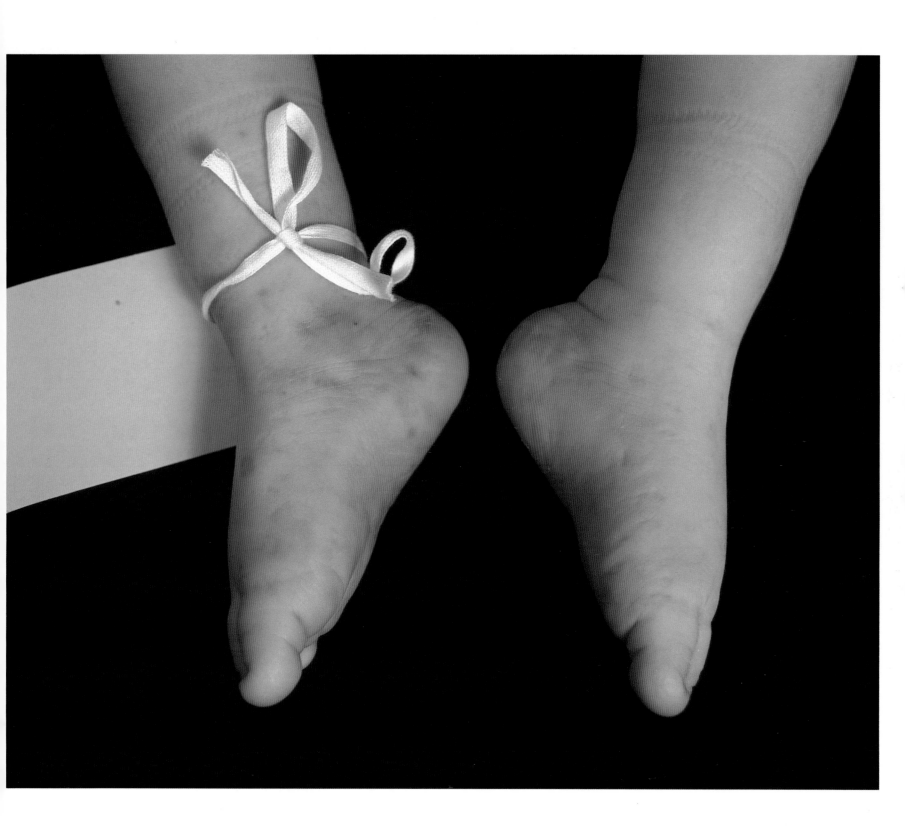

The Morgue (Fatal Meningitis), 1992

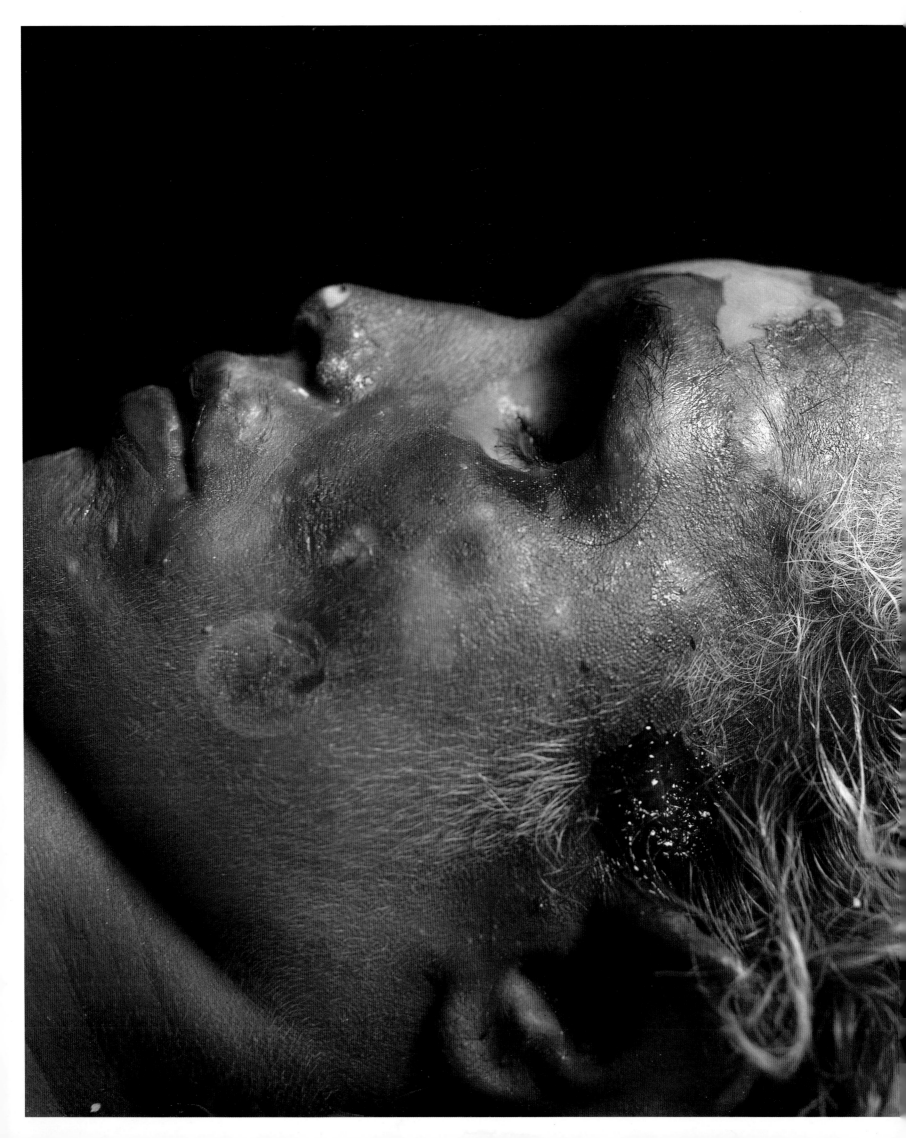

The Morgue (Jane Doe Killed by Police), 1992

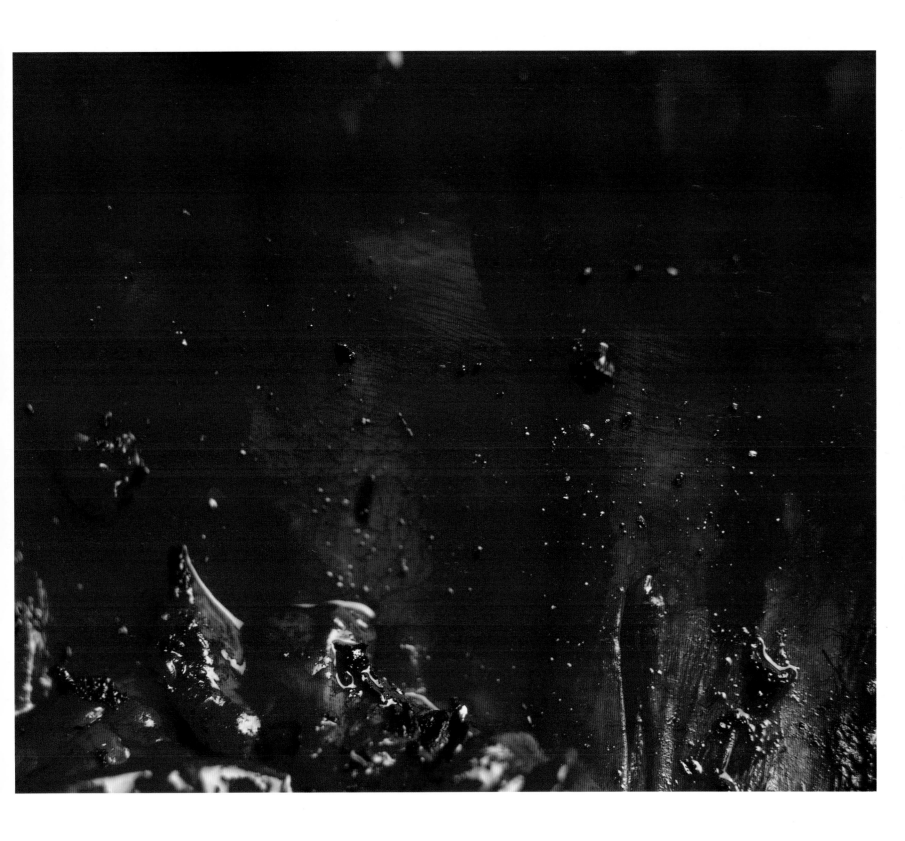

The Morgue (Burnt to Death III), 1992

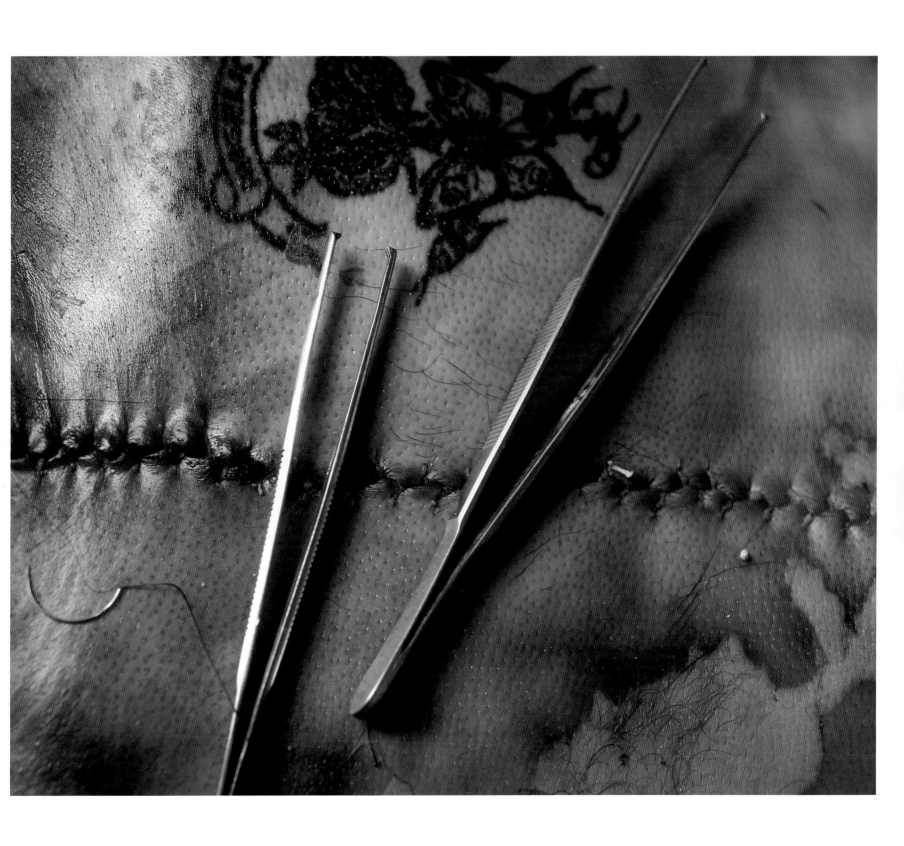

The Morgue (Drowning), 1992

The Morgue (Infectious Pneumonia), 1992

Budapest (Mother and Child), 1994

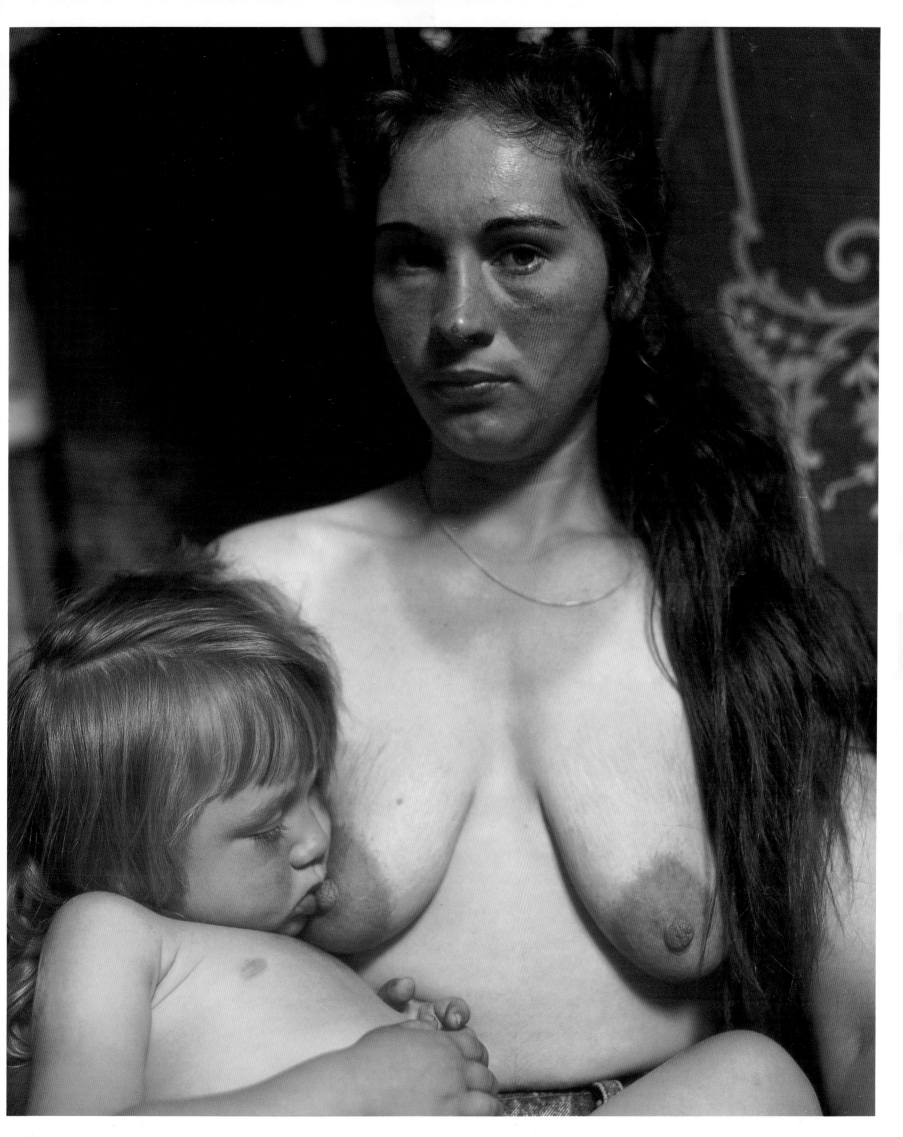

Budapest (The Gellert Hotel), 1994

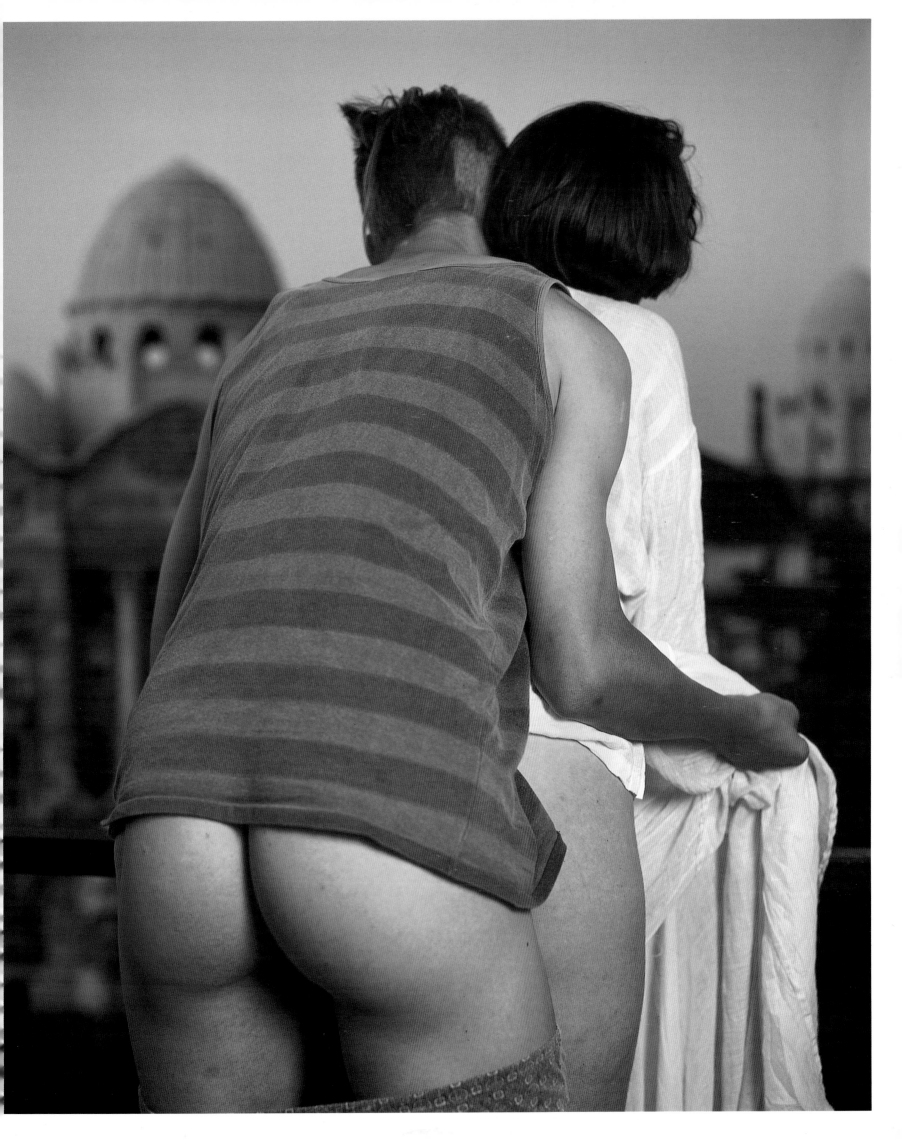

Budapest (The Model), 1994

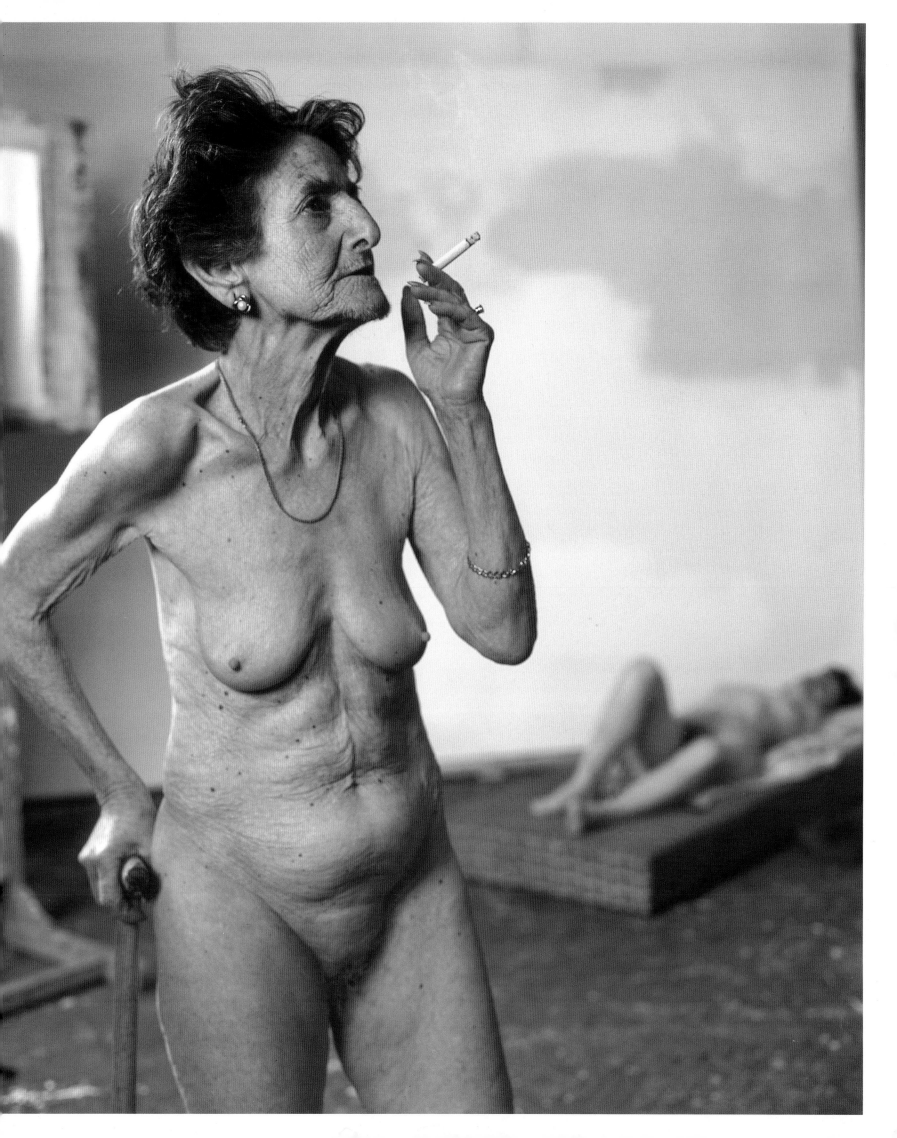

THE REVELATIONS OF ANDRES SERRANO BY AMELIA ARENAS

What pleasure is to be found in looking at a mangled corpse, an experience that evokes revulsion? Yet, wherever one is lying, people crowd around to be made sad and to turn pale…as if some report of the beauty of the sight had persuaded them to see it.
—St. Augustine, *Confessions*

Andres Serrano's photographs inspire in viewers an unsettling mixture of empathy and outrage. Perhaps what is most outrageous about Serrano is the way he manages to call up in us cultural and private memories we thought we had forgotten. Looking at the rotting flesh of *Jane Doe Killed by Police* from his 1992 *Morgue* series returns us to the sort of confrontation with mortality that must have compelled people to conceive of the soul. But the same image can also bring us back to our own morbid moments, those times during mourning, when we have tried to imagine the physical changes taking place in the corpse of someone we loved.

For these reasons, Serrano's works are among the most shocking images in contemporary art. But they are also among the most traditional. They remind us of the lasting impact that the metaphors of Christian art have had on our imagination and ideas about life and death. Beyond that, these images of putrifying flesh tug unexpectedly at the primitive appetites lurking behind those old symbols. It would be tempting to write yet another essay about feeling superior to Serrano's enemies. But we might do better at this point to think about what we share with them—about the arcane forces that have dwelled in pictures for centuries, tightly harnessed in a machinery of signification that Serrano's pictures manage to dislocate.

Serrano's icons of the mid-1980s are articulated and photographed with the visual rhetoric and immediacy of Baroque art. Strictly speaking, these vivid compositions are still lifes, which share with their precedents in post-Renaissance art some significant features. The still life reached its high point of popularity in Europe in the seventeenth century, within an art market increasingly dominated by the merchant class. As it mimicked the array of food on a dinner table or the display of fresh game on a kitchen wall, the still life flattered its owner by suggesting the bounty that might be found at his own table.

On the material level, the Baroque still life was a reminder of rapacious human appetites, for the tasty, the beautiful, the overripe. Implicitly, however, every still life painting was also a philosophical object, an allegory that used the image of food to teach a moral lesson about the earthly limitations of the flesh. Contemplating one of those sensuous pictures today, one can still be struck by the melancholy realization that the fruit so lovingly depicted must have shrivelled well before the painting was finished. A still life, therefore, is always a picture of dead things, a *naturaleza muerta*. In a Christian context, this message has theological implications: just as the painter's artifice preserves *the image* of the food, so too our soul might live eternally through Christ's Salvation. The traditional still life was, therefore, a reminder of Christ's sacrifice and of the Final Things—Death and Resurrection.

In pictures such as Serrano's *The Passion* (1984), the meanings of the Christian still life are stated in a language that is at once more literal and more arcane. His photograph juxtaposes the carcass of a lamb with a mass-produced ceramic head of Jesus as the Man of Sorrows. Linked to the head of Christ, the lamb—itself a familiar symbol of Christ's Sacrifice—becomes an explicit reference to the spiritual sustenance only implicit in the old allegories. Fresh from the butcher's shop, the flayed animal is an aggressive reminder of the decomposition of the flesh, a grotesque counterpart to the elegant arrangement of the food generally found in Baroque paintings.

To be sure, the lamb's carcass, reaching forth, seems to give renewed pathos to the stock repertoire of gestures that have constituted the image of the suffering Christ in the popular imagination: the tearful eyes, the parted lips, the tilted head. But Serrano's picture is more than an update of this traditional type. In its specificity and realism, *The Passion* provides a sense of the immemorial origins of this image and the collapse of the delicate allegorical logic that perpetuated it. Serrano's lamb is no longer the familiar symbol of the victimized Christ, but a totem—a beast that must be killed and eaten, so that it can live in us.

The constant reenactment of totemic death in the Christian mass, as well as in "primitive" rituals, has a soothing, promising effect. It provides the devout with some sense of control over their fears by transforming their violence into identification. But in front of Serrano's *The Passion*, far from feeling empathy and pity, as one might before an image of the suffering Christ, we experience the pounding guilt of his murderers.

Look also at the dead coyote in Serrano's *The Scream* (1986), hanging frozen in the midst of a bloody howl. The rope around the animal's neck turns the image into something terrifyingly human, like an execution. After all, this is not how coyotes are killed. (Serrano bought the carcass from a farmer who had shot the animal, and then hung it up.) Again, however, we encounter the surprisingly anthropomorphized features: the gasping mouth, the head twisting in pain, even the slight tilt of the head. The iconic simplicity of the composition, the vertical orientation of the carcass, even the motif of the rope recalls the images of Christ, bound to the column in scenes of the Flagellation, or exposed to brutal voyeurism in the *Ecce Homo*.

Reversing the logic of the traditional metaphor, Serrano's picture makes us see the feared beast in the vulnerable god.

Something of this sort goes on as well in *Cabeza de Vaca* (1984), a picture of a cow's head, which nevertheless brings to mind countless devotional images of the Lamb of God. Take Zurbarán's *Agnus Dei*, for example, in which the Lamb is represented just before the sacrifice, bound and poignantly submissive. By contrast, Serrano's cow is already dead, its disembodied head casting upon us the sly gaze of an embittered victim. It is as if Serrano had returned to the traditional iconography to make a picture not of the Lamb's sacrifice but of the anxiety inspired by the animal's unbearable vulnerability, turning a traditional symbol of hope into a symbol of divine vengeance.

Although Serrano has refered to Marcel Duchamp as a major influence on his work, Serrano's icons owe less to Duchamp's notion of aesthetic distance than to a Baroque passion for aesthetic overload. Seeing the image of Christ in a lamb's flayed carcass or His anguish in the bloody snout of a dead coyote seems to press our desire for aesthetic arousal to the point of nausea. Serrano's images provoke in the viewer an avalanche of associations, ranging from utter disgust to an atavistic return of the fear of God.

The images Serrano made in the early eighties though starkly realistic seem artificial. It is precisely the exuberant color of the Cibachrome prints and their grand compositions that make the bloody, blotched, mutilated flesh so assaulting. Curiously, as Serrano's work in the late 1980s moved away from the theatrics of Baroque iconography, it got closer to something more deeply significant in the Baroque sensibility— its theology. In these later works—the various series in which he photographed bodily fluids, such as urine, semen, and blood— the representation of mortality shifted from being merely a manipulation of bodily imagery and symbols to the use of human substances as raw material.

That *Piss Christ* (1987), a plastic crucifix immersed in urine, offended even non-Christians and atheists, suggests the lasting impact that Christian symbols have had on our civilization. But bodily fluids are always offensive, with or without Christ. Out of the context of nursing, even mother's milk becomes disturbing. The miraculous feeding of a saint by a squirt of Mary's milk, the key episode in the story of St. Bernard, was a challenge to post-Renaissance artists, who encountered in such subjects a conspicuous conflict between naturalism and propriety. In art, the sight of blood is often intolerable outside of a moralizing context. By and large, until the late eighteenth century, only the blood of Christ and the saints was represented; and,

through them, license was extended to heroes and noble victims. Before the Baroque, the blood under Christ's Crown of Thorns flowed in a string of lovely patterns or shone in little droplets that hung from His wounds like precious stones. Squirts, stains, or spillings of blood were rare in early depictions of Christ, as if such images would remind viewers of their own unheroic bleeding.

The sight of bodily fluids disturbs us because it threatens the fantasy of our own self-containment and corporeal stability. By reminding us of our body's orifices, it makes us seem permeable—literally, likely to lose our *selves*. Any preoccupation with our fluids seems to put us at the level of infants and animals. In "tribal" art by contrast, human fluids and excrement endow fetishes and emblems, constituting the very substance of the sacred, the stuff of power. A strange encounter between these two opposing attitudes—taboo and celebration—happens in many of Serrano's more recent works.

Unlike Serrano's earlier still lifes, where violent visual juxtapositions restore to us what had been lost in the old Christian symbols, in works such as *Piss Christ*, the image remains transcendent. There is a promise of resurrection in the way the contours of the body dissolve and the limbs become pure, burning light. The red hues of the urine also bring to mind other associations—the blood of the Saviour that drenches us, or the fires of hell in which the image of God's sacrifice perpetually reminds the damned of what they had forgotten. It is the title that lends the image its animistic resonance.

If at first *Piss Christ* reads as the raging gesture of a lapsed Catholic, by figuratively pissing on the image of Christ, Serrano might also have created a new icon of Christ's willing humiliation. Shifting the functions of the traditional Christian subjects, Serrano makes us see the Mocking of Christ in the Crucifixion, reducing all the insults, the laughter, and the spitting that Christ endured to the act of desecration of His image. But the power of Serrano's pictures comes precisely from this way of making the meaning of traditional symbols run amok. One wonders, for example, whether here, Serrano's "sacrilege" might turn into a violent, ecstatic identification with the divine, like the mystic experience of Saint Theresa's coitus with Christ or the miraculous bleeding of St. Francis. Because urine comes from within the body, and the body itself is holy and perfect, human excrement might provide an intimation of the soul within.

Sacrilegious as this idea might seem, it is also deeply rooted in Christian doctrine. One of the fundamental notions in Catholic theology, aggressively revived during the Counter-Reformation, is the physical, creatural nature of Jesus. According to dogma, God the Father revealed Himself to us

The Church (Saint Sulpice V), 1991

through the body of His Son. It is through the suffering and death of Christ that we are allowed the possibility of spiritual Salvation and, after the Last Judgement, of Resurrection in the flesh. Our mortal body, therefore, is the fundamental link between Man and God. We are born, St. Augustine reminds us, "between feces and urine." Here, the eschatalogical meets the scatological, and the image of the Last Things is revealed in the contemplation of the things the body leaves behind.

In 1991, Serrano showed two series of portraits, *Nomads* and *The Klan*, which compel us to revisit yet another side of the Baroque. Looking at the poses of the *Nomads*—a group of homeless people whom Serrano photographed in a studio improvised in the IRT subway—one cannot help thinking of the heritage of Caravaggio in Spain, the noble introspection of the saints of Ribera or the candor of Velázquez's fools. Even Serrano's photographic technique reveals a Baroque bias. The strong light and deep shadows that bite into the richly textured figures of the *Nomads* would have made Caravaggio envy what Serrano's spotlights and Cibachrome film can make of *chiaroscuro*.

In the exquisite silhouettes and uncanny darkness cast by the hoods on the faces of *McKinley* or *Payne* (and, even more explicitly, in his ecclesiastical portraits, such as *Frari Paolo* from *The Church* series), we revisit the pious, quiet images of St. Francis in meditation by Zurbarán. This is the kind of expressiveness that emerged when artists such as Caravaggio began to employ as their models ordinary people, who failed to reproduce in their bodies the studied eloquence of conventional poses. To those anonymous Baroque sitters, to their homely awkwardness, we owe some of the most persuasive images we have of martyrs and prophets.

This invitation to see the virtuous saint in the sufferings of the common man provided Baroque art—and later Christianity—with one of its most irresistible strategies. It is ironic, then, that this appeal to human empathy wound up as the most persuasive propaganda device for the Church during one of the most fanatical and violent periods in its history. Yet, this is precisely the sort of cultural contradition that is forcefully conjured up when we see the humble dignity of the *Nomads* side by side with the haunting silhouettes of the *Klan*—the Saint and the Inquisitor. It is as if Serrano's images meant to lay bare the dialectic underlying Baroque art, letting us see the sadistic fantasies that might have been repressed in the empathy inspired by the martyrs of Caravaggio or Ribera.

This conviction, Aristotelian in origin, that we have inherited from the Baroque, that, in art, empathy and projection lead to the revelation of moral truth, is precisely what is put to the test in Serrano's pictures. Far from explaining anything,

the *Nomads* and the *Klan* incite a disquieting skepticism: on one level, they are just pictures. In their theatrical presentation, the people in these portraits both mask and reveal something of themselves. But the more eloquent the picture, the more abysmal is our sense of what we cannot comprehend, whether it be the lust for racial supremacy or the brutality of poverty. Their images are a sobering lesson about the limits of our understanding and about the magnitude of our questions, and as such they lead to the vertigo of *The Morgue*.

I can't think of another instance in which death confronts us as directly as it does in Serrano's morgue pictures. They are too elegant for the police photographer, and too relentlessly factual for the artist. They have been castigated as exploitative, yet these pictures could not be further from the voyeuristic curiosity one senses at a roadside accident. They're bigger, more explicit, and more naked than anything we've ever seen. They are, if anything, a dare.

Like the mirrors in which beautiful women contemplate themselves in Old Master paintings, the images of these corpses turn suddenly into a premonition of our own fate. As a whole, they bring to mind another traditional Christian motif, the Ages of Man, in which the image of a baby, a lovely maiden, a hag, and a skeleton illustrate with implacable logic the workings of mortality on our flesh and warn us against vanity. An encyclopedia of bodily catastrophe, Serrano's pictures from *The Morgue* seem to illustrate that same process of impending decay, but without the natural structure that forms the basis of that traditional subject. Here, the babies are already corpses. And we will never know whether the charred skeleton in *Burnt to Death* was a man or a woman, an old codger or a lovely teenage girl.

These photographs call to mind the tradition, still alive in Latin America, of postmortem portraits of children. In those pictures, the artist often attempts to recreate scenes of daily life, ironically making more vivid the ineluctable signs of death— the rigor, the pallor, the lifeless shadow of the last gesture. The eloquence of Serrano's photographs of dead children often depends on such morbid artifice. Notice how exquisitely Serrano matches the lilac drape to the still-warm tones of the face in *Pneumonia Due to Drowning II*, picking up the faint purple that is beginning to appear inside the child's lips.

Perhaps the most potent among these pictures are those which, like this one, at first, seem the least threatening. Think of the child that lies cocooned in the folds of that sheet. If it were not for the title, we would never know he's dead. A toddler with a bloody nose and parted lips seems to sleep the way kids do when they're stuffed up. In another image, a baby's chubby hands bear the ID tag of the morgue, held with

a gauze strip, not unlike the one we see on a newborn when we first stare at him through the glass of the hospital's nursery.

One must struggle to look at these pictures again and again, and for long enough to allow the initial terror and revulsion to subside. But surprisingly, at some point in this process, without ever losing their tight grip on us, these images begin to turn into beautiful pictures. Masaccio, David, Géricault come to mind. The carmine drape that veils the aquiline profile of the woman in *Infectious Pneumonia*, setting off her pale flesh, makes you think you're looking at one of those cardinals who haunt Venetian portraiture, intimidating even in sleep. In the alabaster hands of the woman in *AIDS-Related Death* we see a thousand female saints, their hands gathered over their bosoms in the rapture of devotion—Titian's *Magdalene*, Bernini's *Theresa*. But because these are photographs and because of the way Serrano exploits his medium, art history succumbs to the ghosts of one's own private history.

In part, Serrano's process explains what makes us so defenseless in front of these images. His camera seems to hunt for gestures and angles that return us to familiar memories— my child asleep, your friend's dead body. This effect is often reinforced by the photographer's own distance from his subjects. (Most of us get this close to a corpse only at the funeral of a family member.) But at other times, our proximity to these bodies is so terrifying that it threatens to rob us of even those familiar references, as we witness the clinical details of charred, ripped, bloated flesh. Whatever intimacy might be conjured up by Serrano's use of distance is further alienated by the scale of the pictures. Paradoxically, their very explicitness often threatens the visual character of these photographs, overpowering the image of these corpses with intimations of their *smell*.

Nothing—not even the will of the artist—can tame the rebellious meanings unleashed by such loaded subject matter. And Serrano seems to be fully aware of this aspect of his work. He fine-tunes photography's indomitable descriptiveness—the camera's inherent failure to explain anything, even while showing everything—in order to set free the latent meanings of his subject, often releasing a force that artists have, for centuries, tried to harness in the image of death.

The cruel decomposition of the young woman in *Jane Doe Killed by Police* remains for me the most unforgettable of the series. The still-beautiful head seen in profile, with its bleached blonde hair all wet, the eyes already gone, is like a doll's head lying in a gutter. Reading the titles of some of the works in the morgue series—*AIDS-Related Death*, *Killed by Police*, or *Rat Poison Suicide*—one might be tempted to see the series as a kind of memento mori for our apocalyptic age, a sign of our collective self-destructiveness. But the images of natural death are perhaps even more terrifying than the others, because they fail to provide our fantasies with a culprit, except for Nature—or a vengeful God.

It would be tempting to attribute the rare mixture of morbidity and grandeur in Serrano's pictures to his ethnic background. And certainly, the fact that Serrano is a Latino artist or that he was raised in New York City by a pious Catholic mother would explain perhaps the artist's curiosity about the power of religious symbols, or his disposition to dwell in the contemplation of the limits of the flesh. But while Catholicism may have supplied Serrano with certain iconographic proclivities, he has managed to make those obsessions engage us all.

In a broader sense, it would seem that Serrano shares the nostalgia for tradition that we've seen developing in the art of the last decades. But most other recent examples of the appropriation of the symbols and manners of past art are markedly ironic. Serrano has said that he acquired his passion for Old Master paintings by studying works in New York museums. Perhaps because he was spared a conventional artistic education, his take on tradition is neither nostalgic nor parodic. He calls up the ghosts of high art to get us involved in a struggle that is primal and fierce, and he does not find an excuse for it in cultural critique or in the romance of identity.

From the allegorical still lifes from the mid-1980s to the direct confrontations with mortality in *The Morgue*, Serrano's photographs throw us back into battle with a form of visual seduction we thought we had overcome. If his pictures are terrifying, it is because Serrano returns us to old Christian subjects at a time when the theological structure that once held their meanings in place has long since vanished. He reminds us that something deeper than theology and older than Christianity lived in those symbols.

ACKNOWLEDGEMENTS

I WOULD LIKE TO THANK THE FOLLOWING INDIVIDUALS FOR THEIR INVALUABLE ASSISTANCE ON LOCATION DURING THE PRODUCTION OF THESE PHOTOGRAPHS: JULIE AULT, MICHAEL COULTER, HOPE URBAN, RICHARD SUDDEN, SIBYLLE DE SAINT PHALLE, BLAKE BOYD, TRACY SUE THOMPSON, ANNA NYRI, AND HELGA ESZTER RAJZ.

SPECIAL THANKS TO THE PAULA COOPER GALLERY AND GALERIE YVON LAMBERT

COPYRIGHT © 1995 TAKARAJIMA BOOKS, INC. PHOTOGRAPHS COPYRIGHT © 1995 BY ANDRES SERRANO.

ESSAY COPYRIGHT © 1995 BY BELL HOOKS. ESSAY COPYRIGHT © 1995 BY BRUCE FERGUSON. ESSAY COPYRIGHT © 1995 BY AMELIA ARENAS.

ALL RIGHTS RESERVED UNDER INTERNATIONAL AND PAN-AMERICAN COPYRIGHT CONVENTIONS. NO PART OF THIS BOOK MAY BE REPRODUCED IN ANY MANNER WITHOUT THE

PRIOR WRITTEN PERMISSION FROM THE PUBLISHER AND THE COPYRIGHT HOLDER.

TAKARAJIMA BOOKS, 200 VARICK STREET, NEW YORK, NY 10014

TEL: (212) 675-1944 FAX: (212) 255-5731

EDITOR: BRIAN WALLIS

BOOK AND COVER DESIGN: ROGER GORMAN/REINER DESIGN

THE STAFF AT TAKARAJIMA BOOKS FOR BODY AND SOUL IS: AKIHIKO MIYANAGA, PUBLISHER KIYOTAKA YAGUCHI, ASSISTANT PUBLISHER

ISBN: 1-883489-11-3 LIBRARY OF CONGRESS NUMBER: 94-060221 PRINTED AND BOUND BY C & C OFFSET PRINTING CO., LTD, HONG KONG